Larry Merrill

Pedestrian Photographs

UNIVERSITY OF ROCHESTER PRESS

First published 2008
in conjunction with the exhibition *Pedestrian Photographs*
Memorial Art Gallery of the University of Rochester,
500 University Avenue, Rochester, NY 14607, USA, mag.rochester.edu

ISBN-13: 978–1–58046–290–7
ISBN-10: 1–58046–290–1

Library of Congress Cataloging-in-Publication Data

Merrill, Larry.

 Pedestrian photographs / Larry Merrill.

 p. cm.

 ISBN-13: 978-1-58046-290-7 (alk. paper)

 ISBN-10: 1-58046-290-1

 1. Street photography—New York (State)—New York. 2. New York (N.Y.)—
 Pictorial works. I. Title.

 TR659.8.M47 2007

 779'.47471—dc22

<div align="center">2007045624</div>

A catalogue record for this title is available from the British Library.

 UNIVERSITY OF ROCHESTER PRESS

Distributed by the University of Rochester Press, 668 Mt. Hope Avenue,
Rochester, NY 14620, USA, www.urpress.com
and Boydell & Brewer Limited, PO Box 9, Woodbridge, Suffolk IP12 3DF, UK,
www.boydellandbrewer.com

This publication is printed on acid-free paper.

Printed in the United States of America

Table of Contents

For Susan.

Some of the best artists are the best observers. They notice what the rest of us pass by, and recreate those details just convincingly enough to leave us wanting more. Mystery hovers at the edges, for example, in the furnishings of Edward Hopper's spaces and the melancholy expressions of his people, and we are captivated by the quiet perfection of their synchrony.

Hopper was described by John Updike as a painter whose work speaks from "sunlit solitariness" and "quite personal silence."[1] A visit to the recent retrospective at Boston's Museum of Fine Arts underscored for me Updike's words, but led me, also, to reconsider images that had been top of mind for me most recently, the photographs of Larry Merrill. The experience of being immersed in Hopper's work triggered my ability to "see" even more fully the strength of Merrill's work, which may or may not have been influenced by a lifetime of knowing Hopper's paintings. (In reality, no artist working in the realistic tradition in America in the 20th century could have escaped the influence of Hopper, whether conscious or not.) Both use man-made spaces as sets in which people act out microslices of anonymous dramas, unaware that the artist is watching. While Hopper could compose his stage sets with paint and canvas over weeks and months in his studio, Merrill must be more like a collector in search of an elusive and moving target—his work depends heavily on his ability to anticipate or recognize in a split second the right subject and the right composition, and then point and shoot.

[1]John Updike, *Still Looking* (New York: Knopf, 2005), 187, 193.

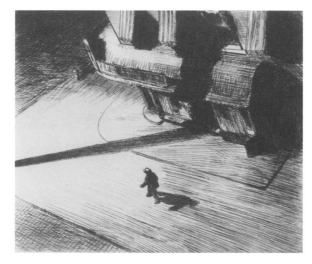

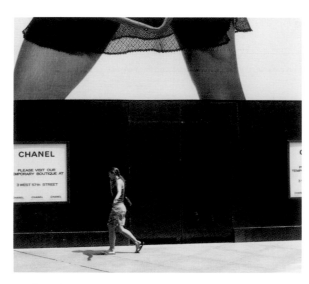

Above: Edward Hopper, American, 1882–1967, Night Shadows, 1921, Etching. Gift of Sister Magdalen LaRow in honor of Robert Gianniny, 89.52

Below: Larry Merrill, NYC 2004 (p. 27)

Against New York City backgrounds, Merrill's people wait for buses, talk on cell phones, and navigate streets and sidewalks while they unselfconsciously function as elements and extensions of street design as well. Noise and activity frequently surround them—what could be more symbolic of noisy intrusion than the cell phone in public space?—but as in Hopper's painting, the mute button is pushed and the strollers, talkers, waiters, smilers freeze, caught for all time in their awkward humanity, leaving the viewer to construct the rest of the narrative. Meaning-makers that we are, we habitually fall into the habit of storytelling, and so risk overlooking the richness of color and composition—the strong diagonal, the omnipresence of the black and white palette punctuated with sharp bursts of color, the textures and the distinctive quality of light.

Merrill and Hopper part company along the way, particularly in their approach to women. Hopper's women are often disengaged and disappointed. Devoid of energy, they seem trapped within their lives, perhaps extensions of the emptiness that characterize the rooms in which

they're painted. Merrill's women, by contrast, are free and autonomous, with the world wide open to them—from the elderly woman whose profile is topped with a picture hat, to the tourists at ease on a city street-corner. He approaches them with tenderness, aware that he is taking advantage of their lack of self-consciousness, and we can nearly imagine him asking for forgiveness for focusing on their too-tight white pants and their unmanicured feet. Tenderness mixes with humor, as the pedestrian in flip flops is nearly mocked by the glamorous legs in large scale in the advertisement above. Merrill never misses an opportunity to poke fun, but he does it gently.

Historically, Merrill continues the tradition of the artist as voyeur—not necessarily in the erotic sense, but by disregarding the good manners that most mothers taught with the admonishment "Don't stare!" It is by staring and using the camera as a tool for doing so that some of Western culture's finest artwork has emerged. While we may experience a temporary thrill because, in these works, we can look ceaselessly at people from whom, in real life, we would ultimately have to look away, the experience can also be an opportunity to practice artful staring. Immersion in Merrill's work, enriching for its own sake, can remind us to use our own eyes to observe, frame and compose; to select from the stage set that is our world a visual vocabulary of details and qualities that characterize the subjects that enliven, intrigue, and engage us.

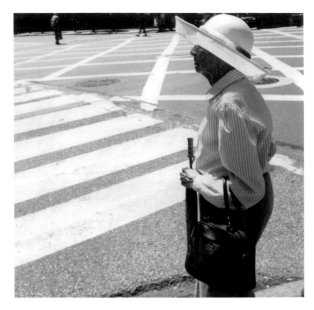

Larry Merrill, NYC 2006 (p. 36)

Marjorie B. Searl

Marjorie B. Searl is Chief Curator at the Memorial Art Gallery of the University of Rochester, where she organized the travelling exhibition Leaving for the Country: George Bellows in Woodstock. *She edited and wrote for the Gallery's first catalog of its collection of American art,* Seeing America: Painting and Sculpture from the Permanent Collection of the Memorial Art Gallery of the University of Rochester.

Larry Merrill and I are friends, you might say, by inheritance. We inherited each other from our mutual friend, the writer and critic Ross Feld, who was one of the brightest, dearest people either of us has ever known. It is easy for me to imagine that if Ross had lived, he and not I would be writing this essay to accompany Larry's pictures.

Ross would have seen Larry's work familiarly, as a New Yorker. His view of them would have been of the keenest interest to me, because I see them necessarily from a distance. Larry, in his letter to me when he sent me prints of these photographs, wrote that what I would have to say would interest him "exactly" because "Manhattan is not Port William."

Port William is the name of the fictional Kentucky town, population of maybe one hundred, that I have been writing about in novels and stories for most of my life. Port William is in some ways similar to the actual town of Port Royal, the neighborhood of which has been home to me all my life, and where I have lived since 1965.

Before settling here, my family and I lived in New York for two years. For the longest and best part of our time there, we lived in a loft on Greenwich Street, not far from City Hall, and I rode the subway from there to my job in the Bronx. These photographs take me back to our time on Greenwich Street, and to what I learned then by being there from a distance.

After we had grown used to our place there and to the pattern of our comings and goings, I would sometimes be exhilarated by the thought, "Everything is here!" That surely was an overstatement, and yet even now when I visit New York I still feel that if only I knew where to look in the great maze of its streets and buildings I could find almost everything.

And I was fascinated by the numerousness and the endless shiftings of the crowds in the streets and on the subways. At first, after following the thread of my own direction among so many people, so many other directions, I would be exhausted mentally and physically. What could have made me so tired?

I finally figured it out. I was so tired because I had been looking at all those people, trying to arrive at some accurate impression of each one, as if I were meeting them on the street in some much smaller place—some place where people, in meeting and passing, might comfortably look at one another, or even nod or smile or speak. I was allowing those people to interest me. Who were they? Where were they going? Were they happy or unhappy? Did they or didn't they seem to be people I would like to know?

Maybe I was on my way to becoming a New Yorker myself when I learned that you must not do that. You had, so to speak, to be in the crowd but not of it. When you walked in the street you must see the crowd but not the people. When you rode the subway, if you could find a seat, you would read a book; if you had to stand, you would read the advertisements. At least you had to avoid all that would be implied in actually looking at all the other people, whom almost surely you had never seen before and would never see again.

My interest in this set of photographs begins with the realization that, in making them, Larry deliberately violated the rule of inattention. He has presumed to make himself exceptional by looking at these people, most of whom are not looking back, at him or at anybody. These people have mostly accepted their anonymity and invisibility to one another. They mostly are not looking at much of anything, and they are not thinking of themselves as seen. To alter T. S. Eliot a little, they have not prepared a face to meet the faces that they meet.

There is, maybe inevitably, a certain humor in this catching of people unaware. Four young women are posing to have their picture taken——but not, so far as they know, by Larry Merrill.

A woman is looking into a shop window, but not at the merchandise on display. She is looking at herself. She is fixing her hair.

A woman with fairy wings and an impromptu ponytail stands on tiptoe to examine the wares of a "side walk cafe." Beside her stands perhaps a clown wearing probably an improbable blond wig. This is the comedy itself of the Manhattan streets, where if Beowulf or Charlemagne or Venus naked walked by unaccompanied by sirens and a band, nobody would look.

There is nothing of voyeurism surely in looking openly at people who conventionally don't care whether or not they are seen, and yet these photographs carry an insinuation of privacy revealed. Their intimacy is surprising and moving. These displays of human vulnerability, of human fleshliness and mortality, would not of themselves detain us as fellow passers in the street, but captured and held still in these photographs they stop us and draw from us a tenderness all the more poignant for its uselessness. A varicose vein peeps out of the slit in a woman's skirt. People are waiting for a bus, for the arrival of a friend, for a light to change, but their patience is not expectant like that of a fisherman, or perhaps a photographer; it is submissive. They are submitting to a hiatus in their day and their life; they will resume their lives again when what they are awaiting has arrived. Because the people are so plainly out of touch with one another, their clothes become acutely touching; we become aware of the inward intimacy of their clothes. We are moved, remembering Eliot again, by "The notion of some infinitely gentle / Infinitely suffering thing." Each one belongs in a story from which others in the picture and we and the photographer are excluded. Here in the common street, which abstractly signifies their common humanity and community, they seem to be in suspension, known only to themselves, outside their stories, nameless.

There is certainly something attractive in their anonymity, and a kind of freedom. Because of it, according to one of the dominant clichés of modern life, they are not oppressed by the proprieties of small town life, or by the "mind-numbing" work of rural economies. But anonymity signifies isolation too, and it carries the premonition of loneliness. That is why these scenes communicate congruence but not coherence. Cell phones, which supposedly keep us connected, work in these pictures as emblems of isolation and inattention. So perhaps do sunglasses. Where are the open countenances that would tell us of recognition and mutuality? That young woman rushing along in her dark glasses, talking on her cell phone: Where, in her own mind, is she? To whom is she present? In the pictures that show only the legs and feet of people waiting at stoplights, you can see again the stance and the attitude of unawareness; these people are not seeing one another.

The most poignant, to me, of all these photographs is the one in which a man and a woman are brushing past each other, almost colliding, in a crosswalk. This is another event without a story. Might the man have swayed over so as to touch the woman in passing? Are they aware of each other at all? But they could almost be performing an allemande in a square dance, looking ahead in opposite directions to their next partners.

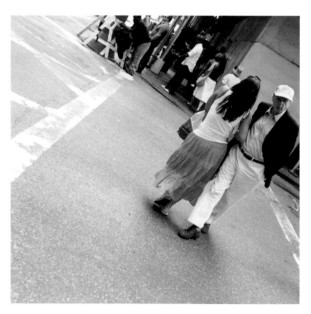

Larry Merrill, NYC 2005 (p. 38)

What is the unifying element—the ground—of this set of pictures? I think it is the ubiquitous pavement of the sidewalks and streets. Apparently the photographer thinks so too, for he deliberately directs our attention to it. At times he seems to notice the vastness of it. And maybe it is not until you get to the park scenes with their patches of green lawn (these come late in the arrangement that Larry sent to me) that the point about the pavement comes clear: its hardness, heartlessness, and sterility. Nothing can take root in it or live from it, though much can die upon it.

Thinking of these scenes so often and so portentously paved, I was reminded of something I will hope to forget again: a man crumpled on the sidewalk at the foot of one of the tall buildings on Washington Square, his body so suddenly quiet in its ruin, the pavement unimpressed.

Well, the pavement happens to be continuous from Manhattan to my small town or to any other in the United States. And when you arrive at whatever small town, you will find, though perhaps not yet so well perfected, the same conventional inattention, isolation, and anonymity, the same congruence without coherence, that you left in the great metropolis.

The derelict neighborhood where we lived on the lower west side in the early sixties had once been a local shopping center with its own small shops and its own more or less indigenous population. A few people still were living there who had been born there. When we lived there, the place had about been absorbed into the generality of the life of the city. When I went back a few years ago I recognized nothing except the names of the streets.

Going to and from my job, I walked every day through a neighborhood shopping center in the Bronx that was still fairly vital. Regular customers still patronized its small shops and its small kosher restaurant. But there too were abandoned business places that were permanently for rent. Small towns in Kentucky were in exactly the same state of decline. The chain stores and volume discounts were ruining at the same time, for the same reasons, the neighborhoods of New York City and the small towns everywhere.

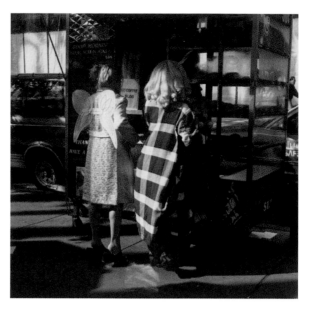

Larry Merrill, NYC 1998 (p. 30)

And so, though I know as well as Larry Merrill that "Manhattan is not Port William," from the perspective of Port William I recognize that Larry and I are citizens of the same direly afflicted country, and I see in his pictures of Manhattan what is happening to us all.

Wendell Berry

Author of more than forty books of fiction, poetry, and essays, including The Way of Ignorance, Given, *and* Hannah Coulter, *Wendell Berry has farmed a hillside in his native Henry County, KY, for more than forty years. He has received numerous awards for his work, including the T. S. Eliot Award, the Aiken Taylor Award for poetry, and the John Hay Award of the Orion Society.*

Photographs

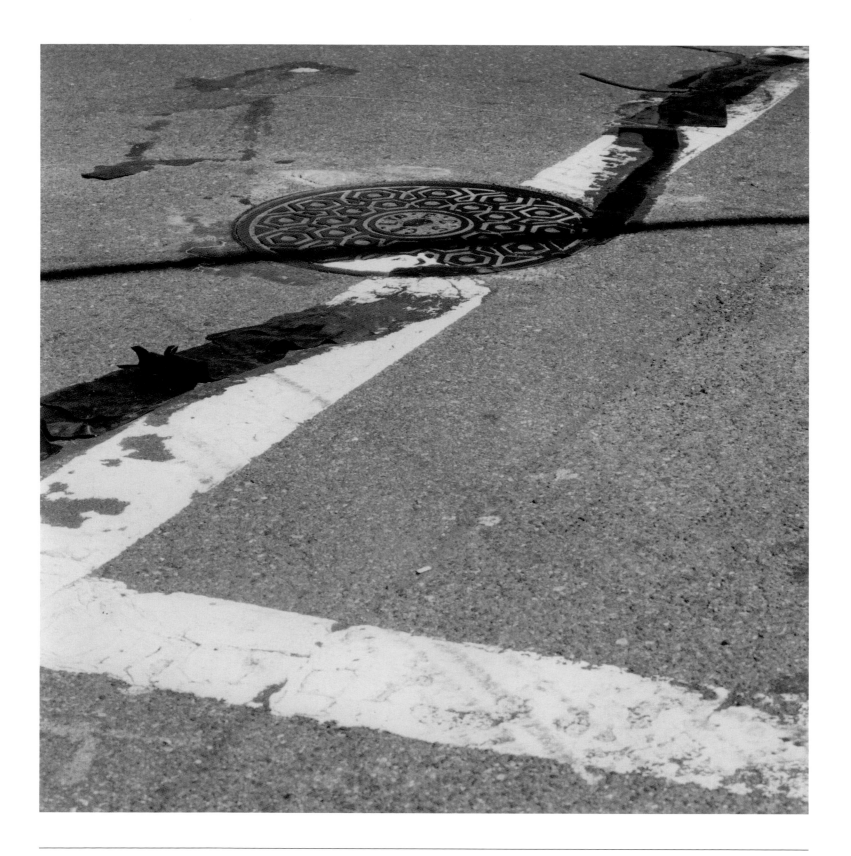

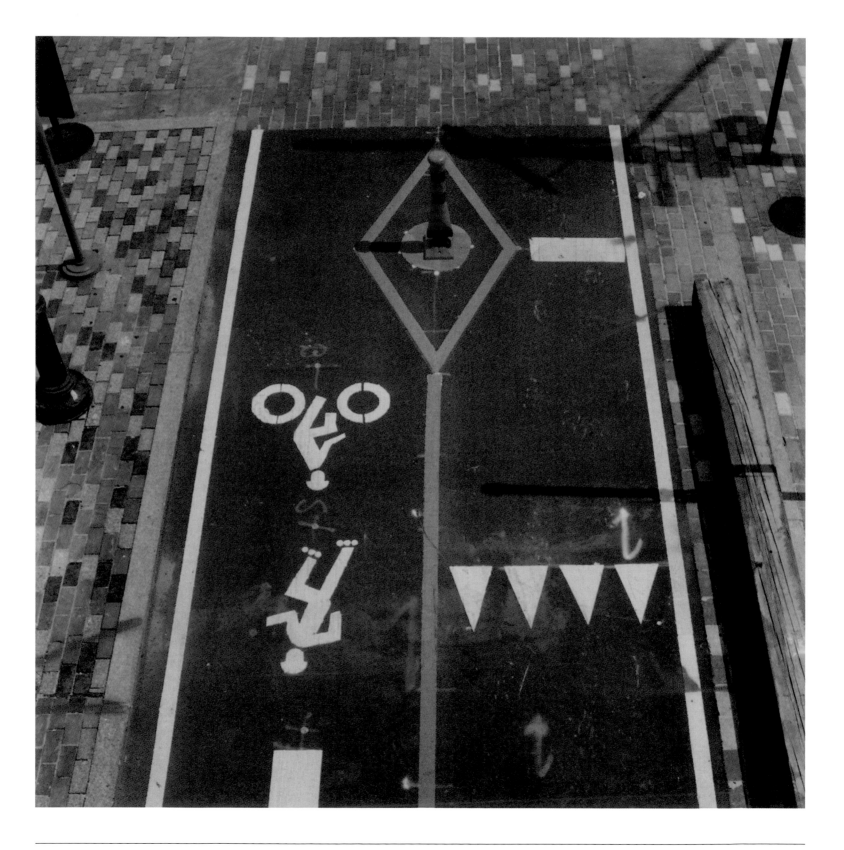

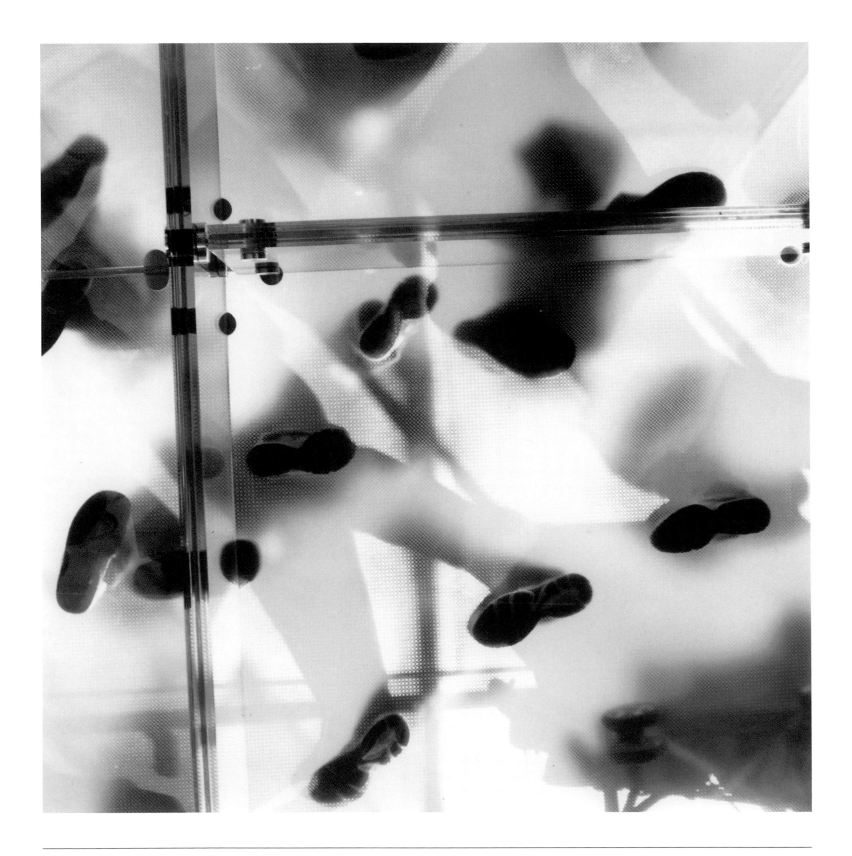

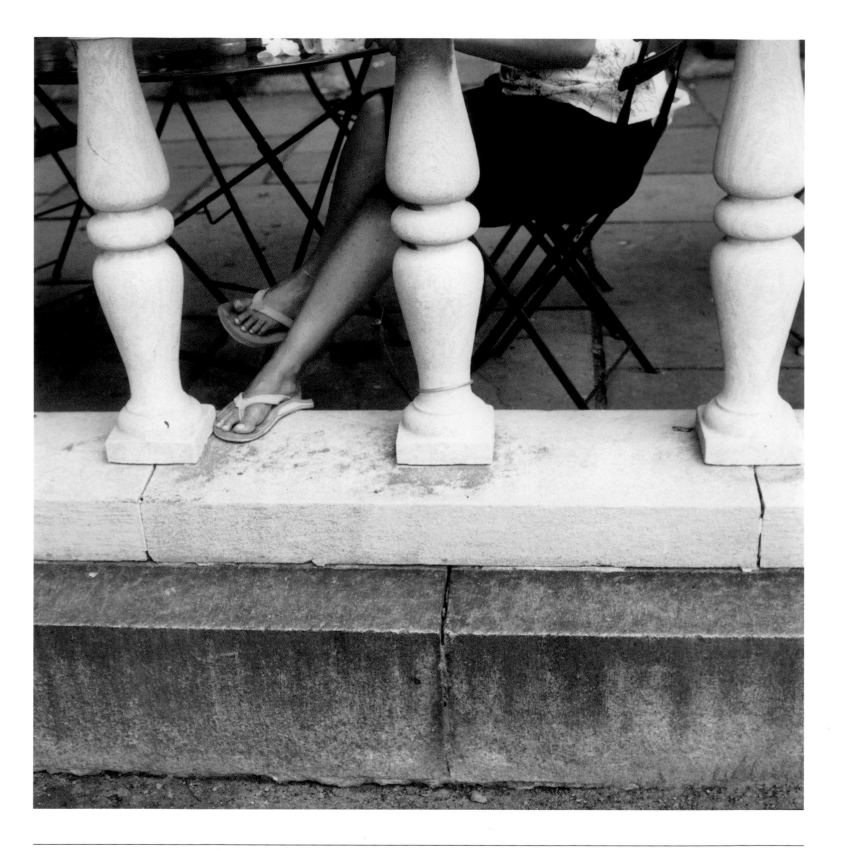

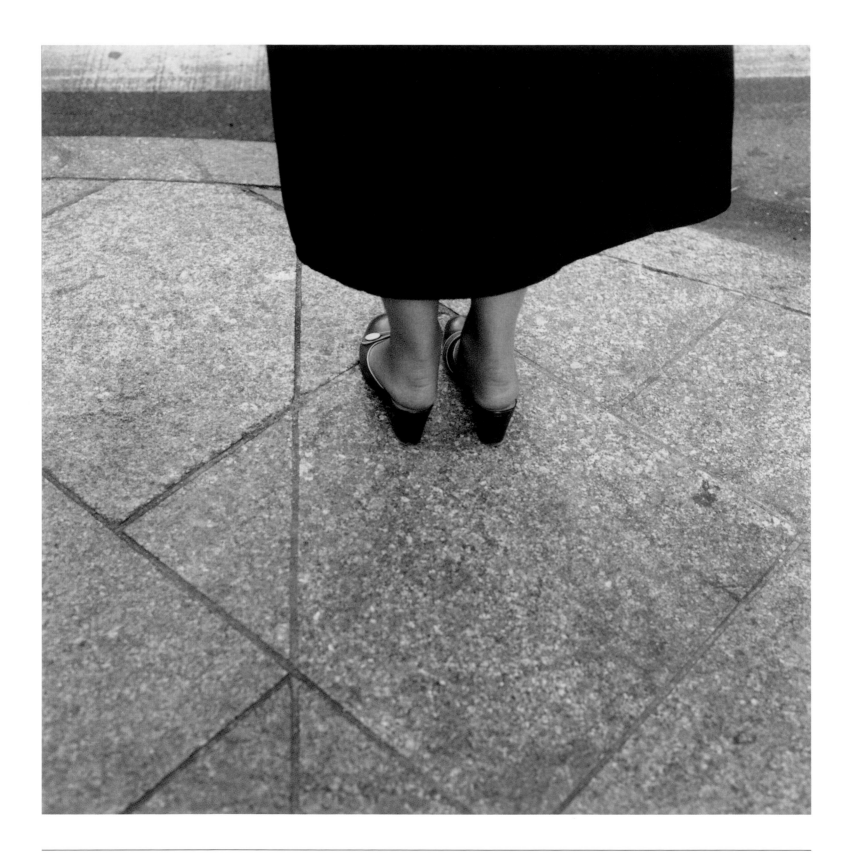

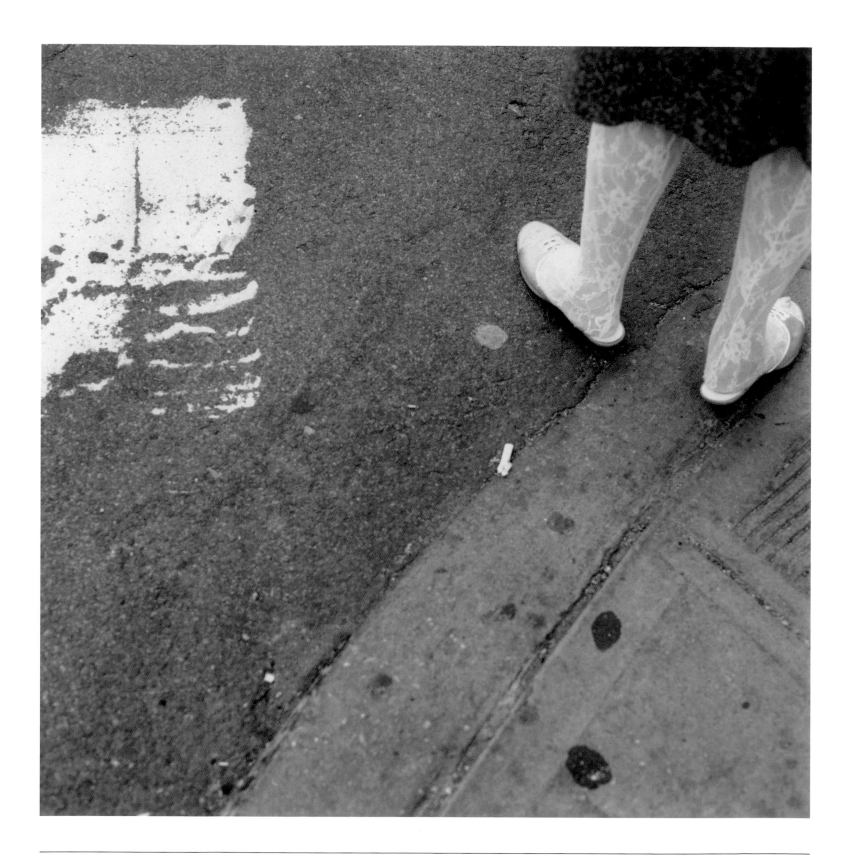

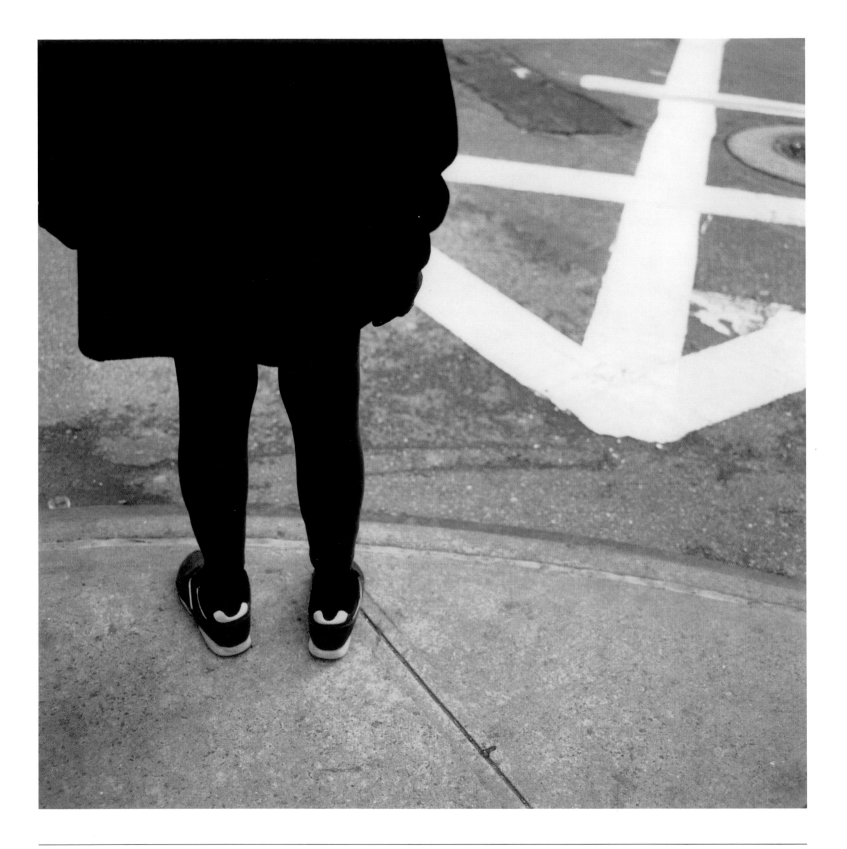

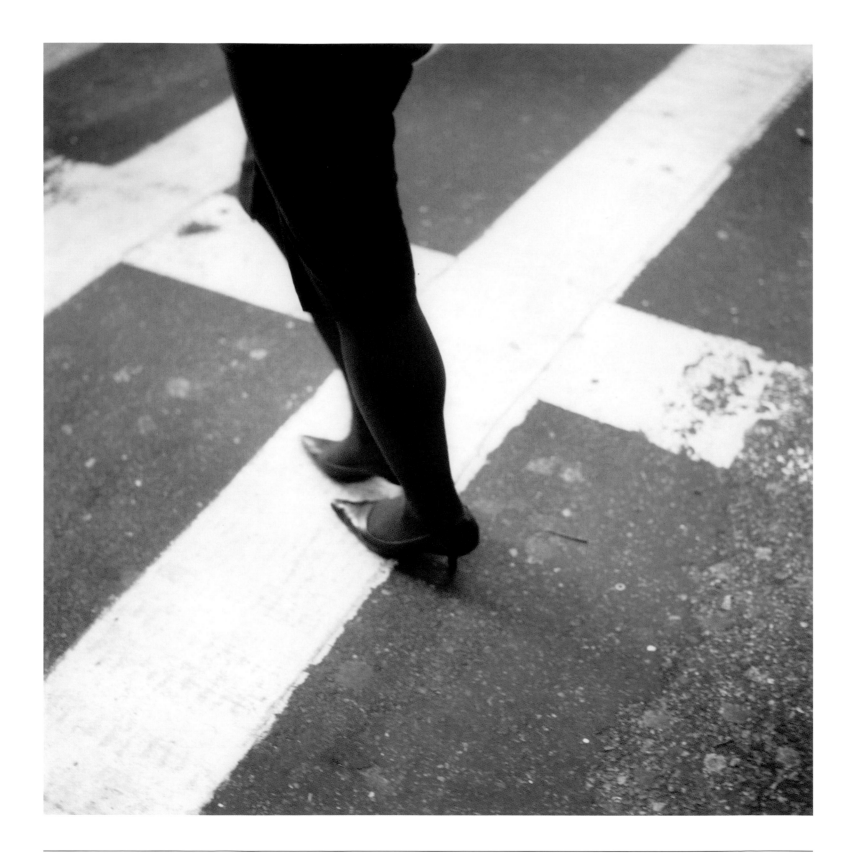

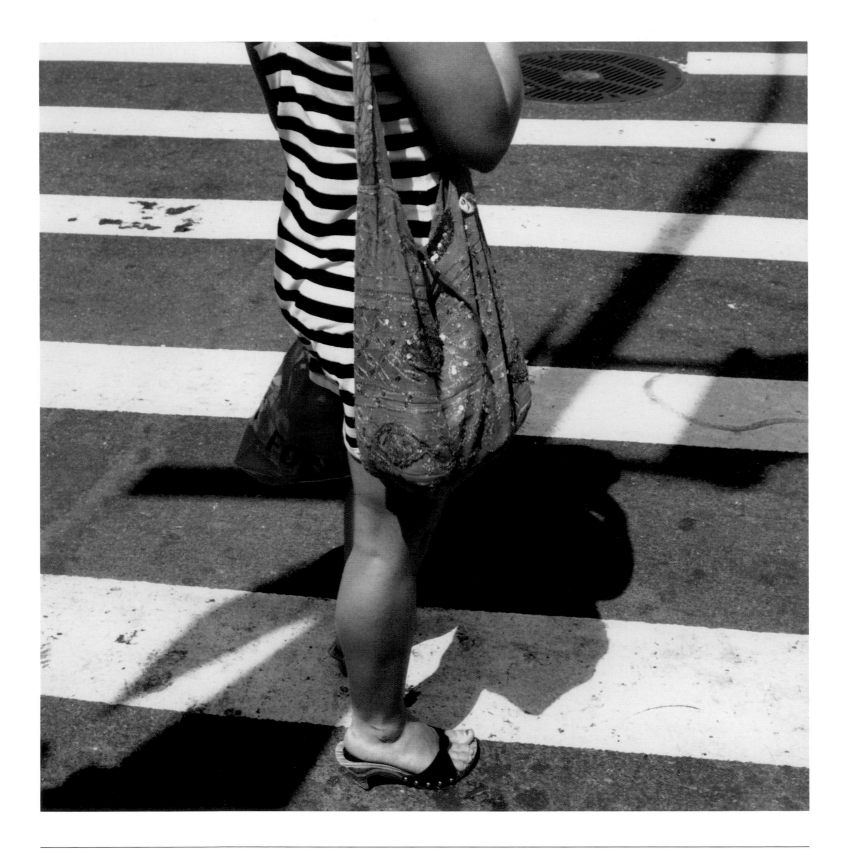

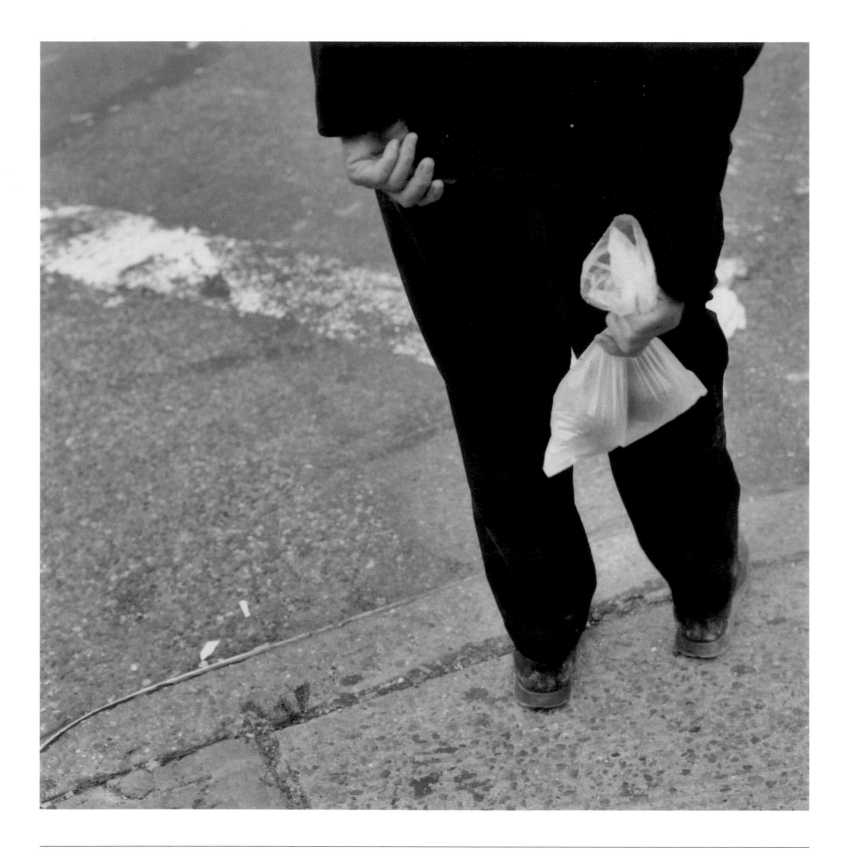

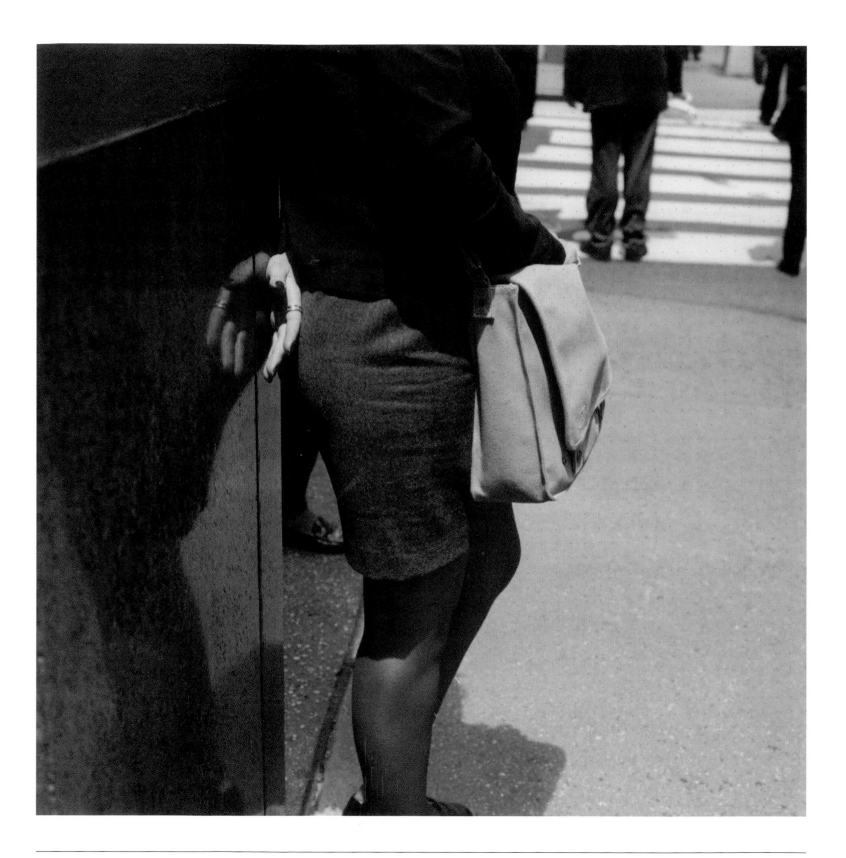

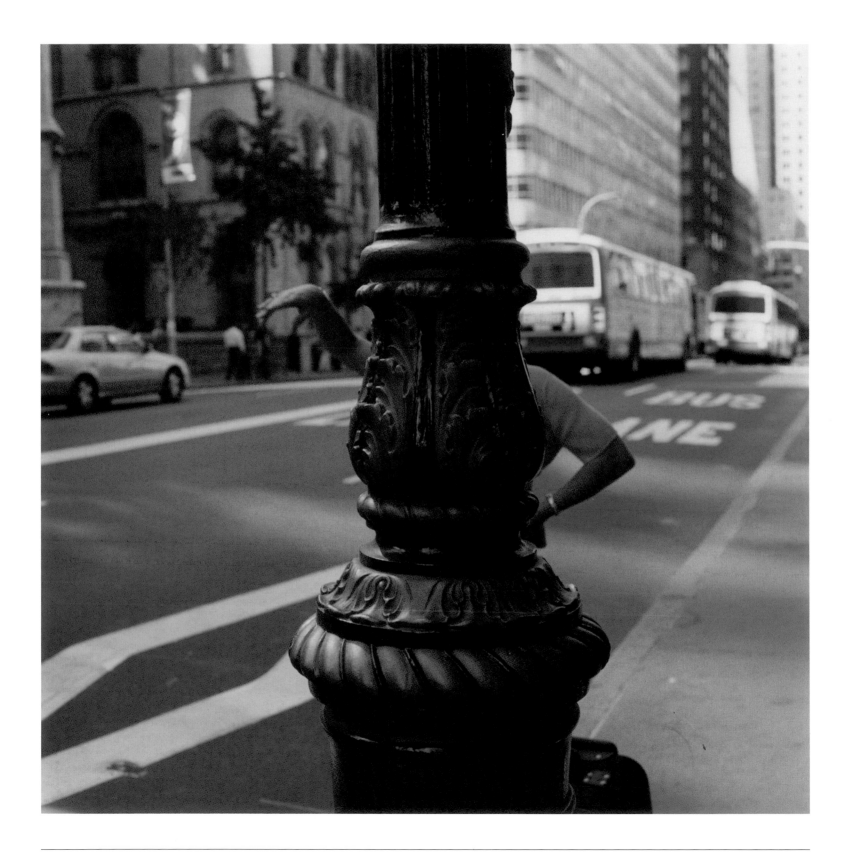

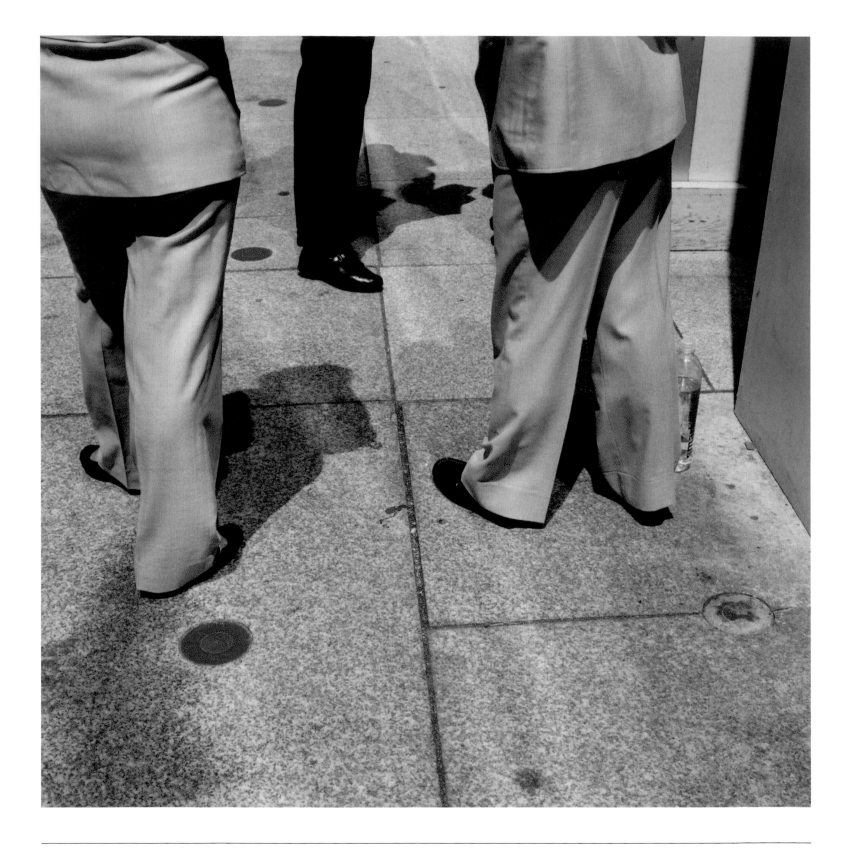

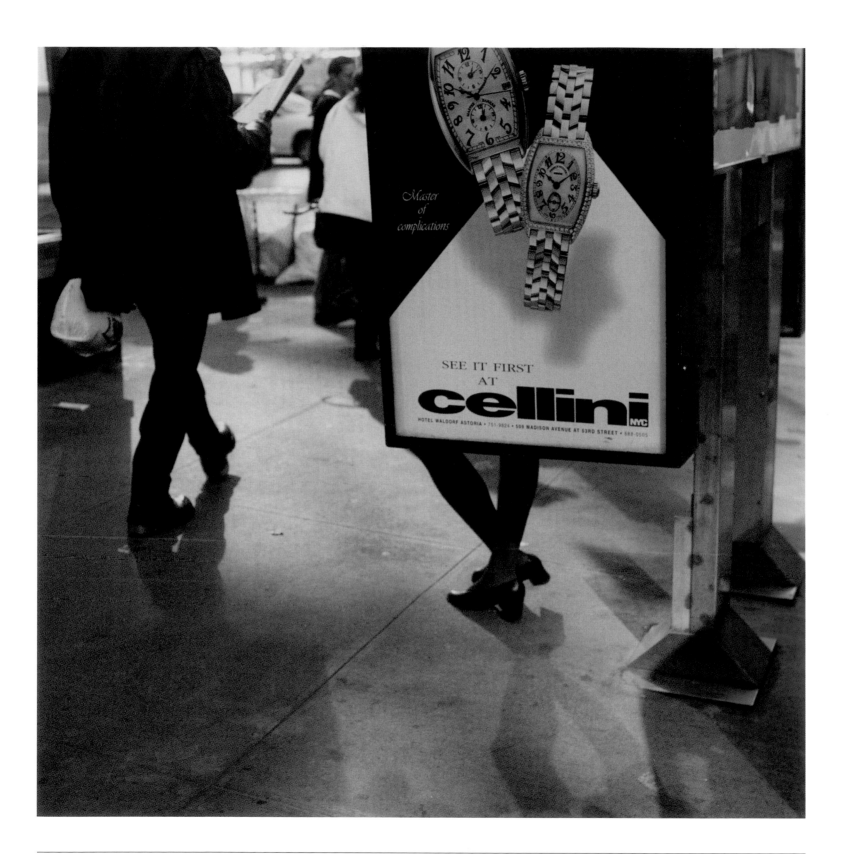

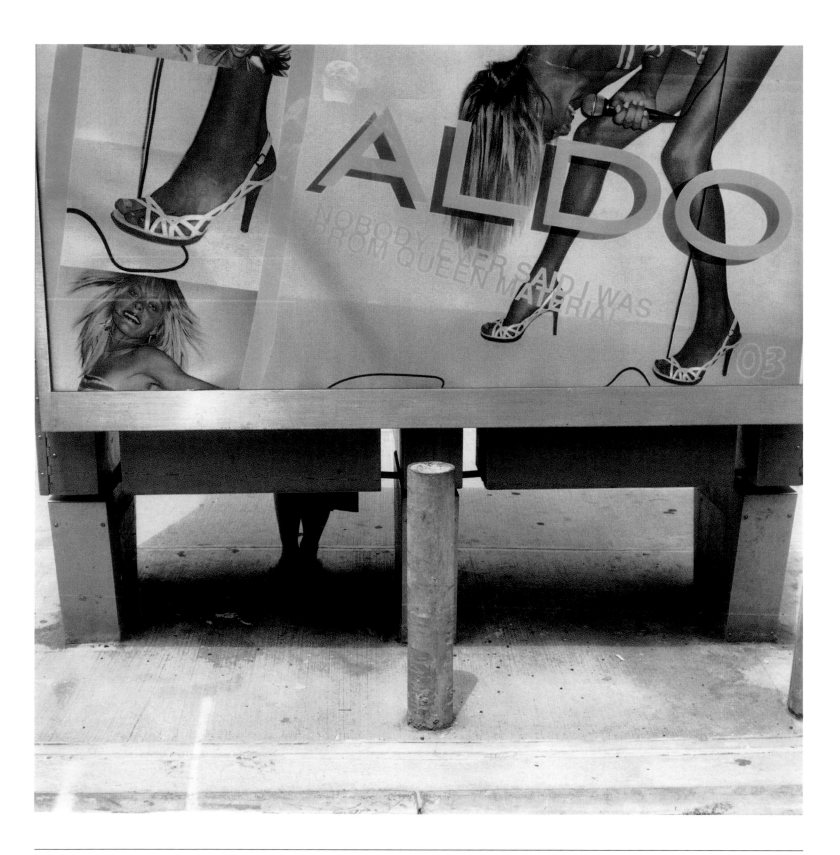

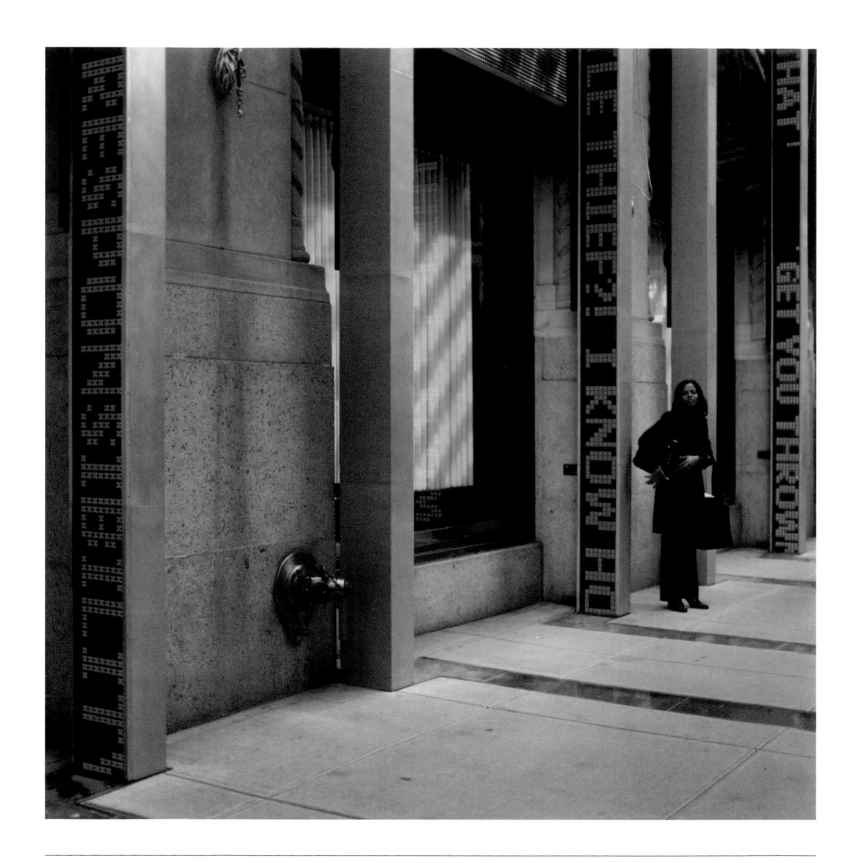

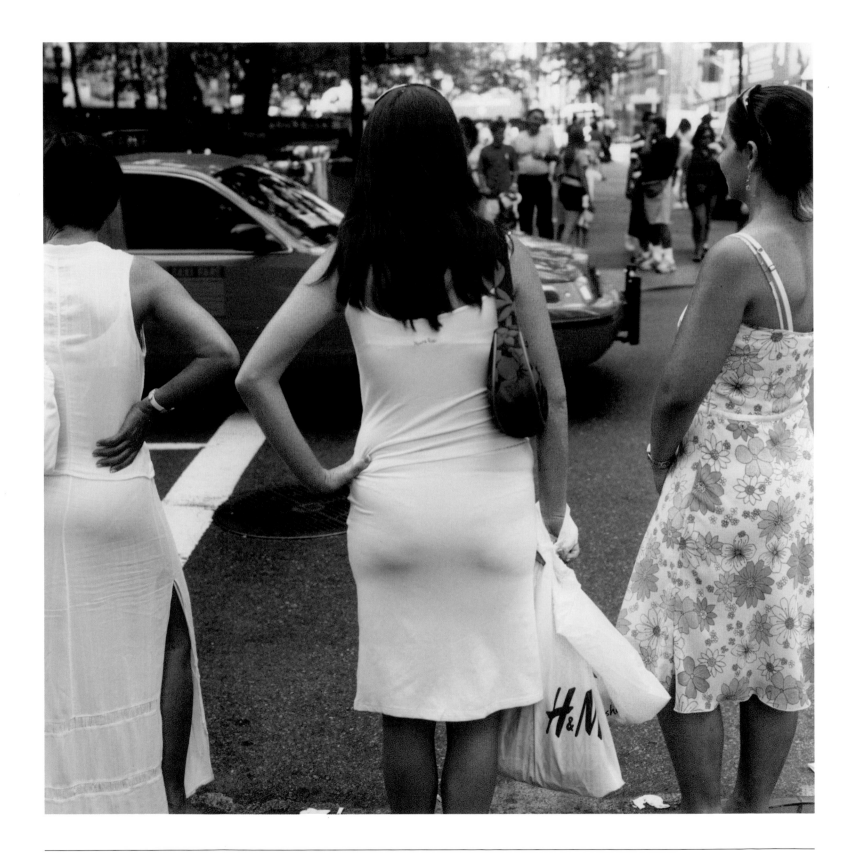

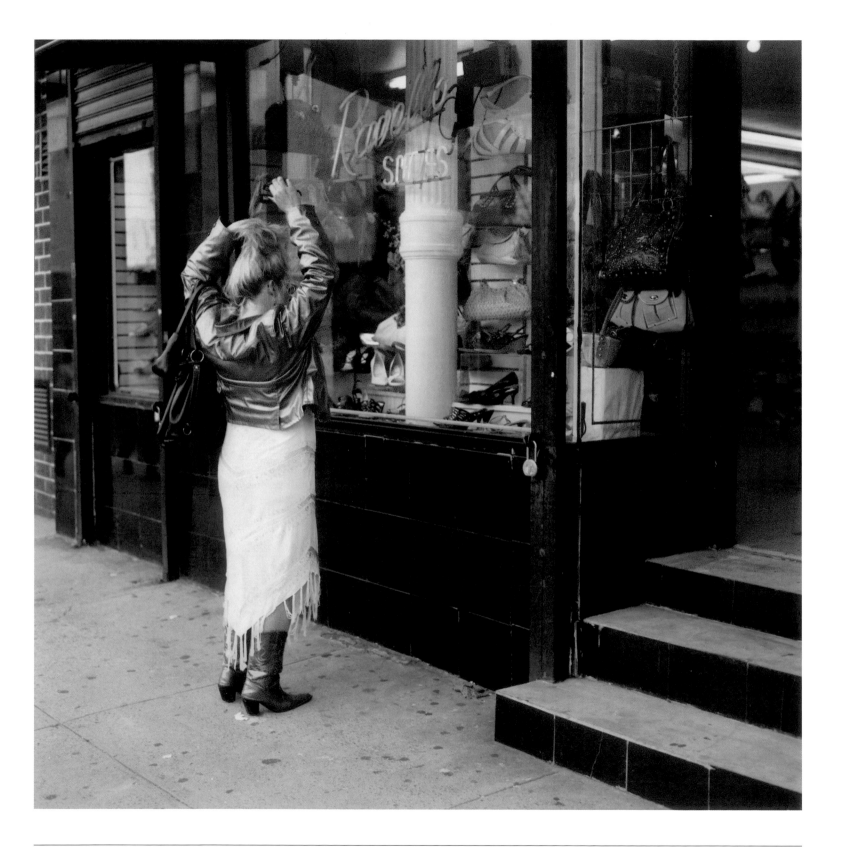

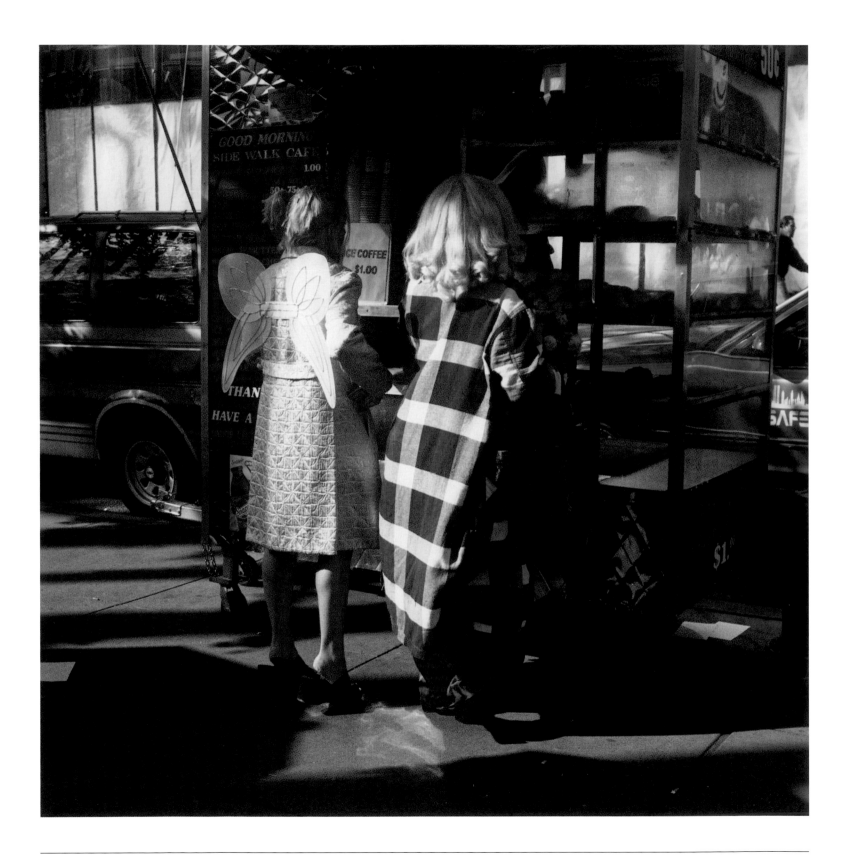

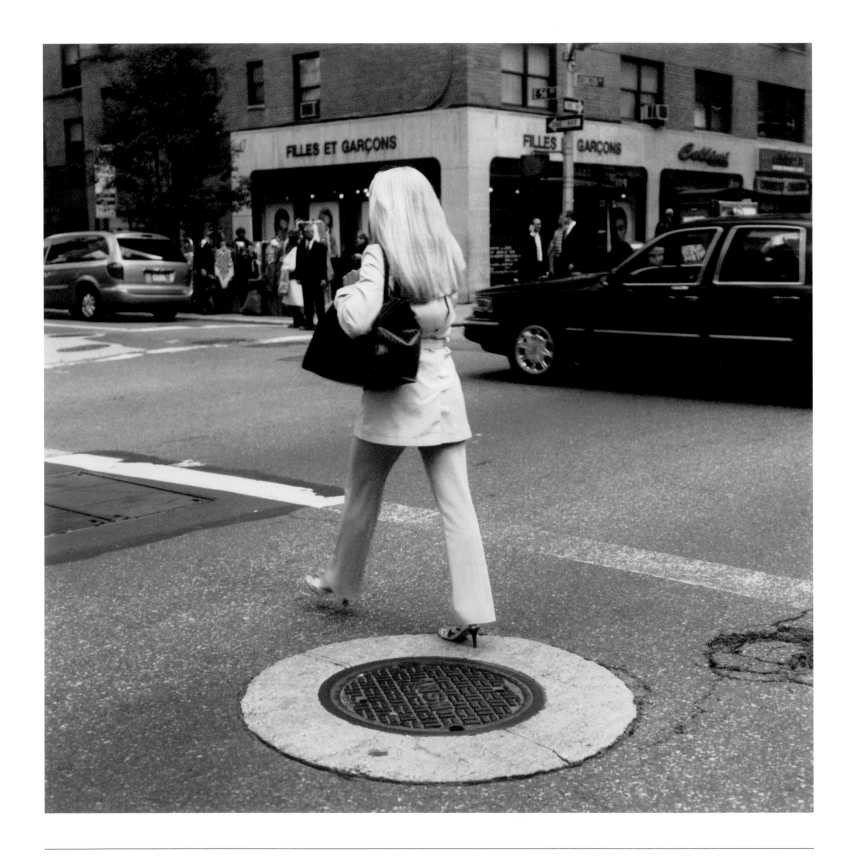

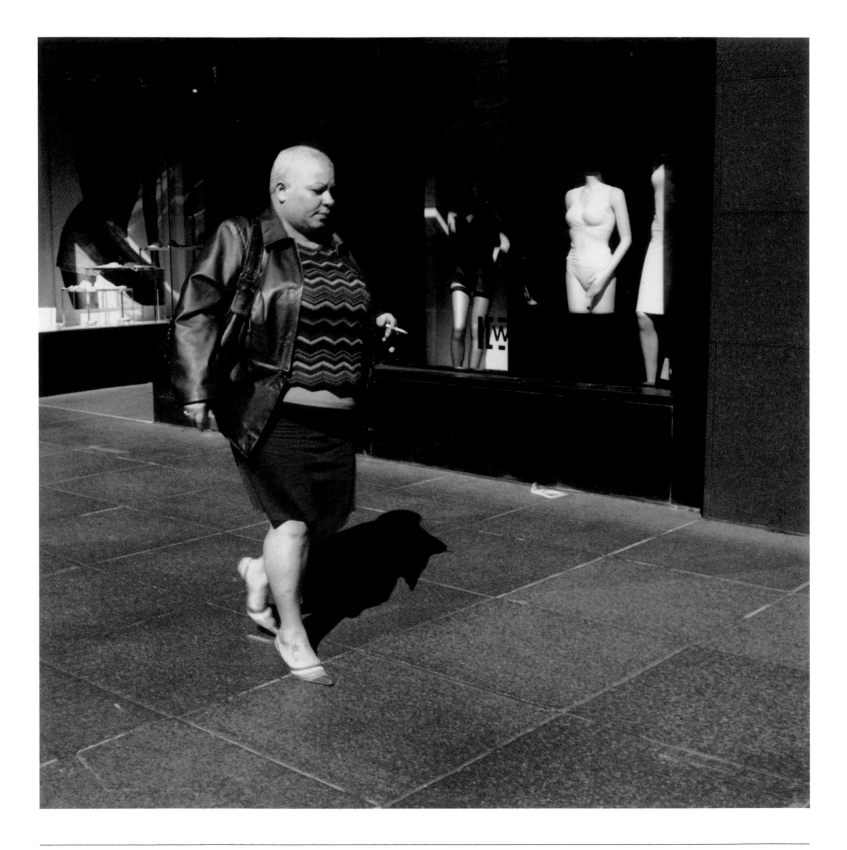

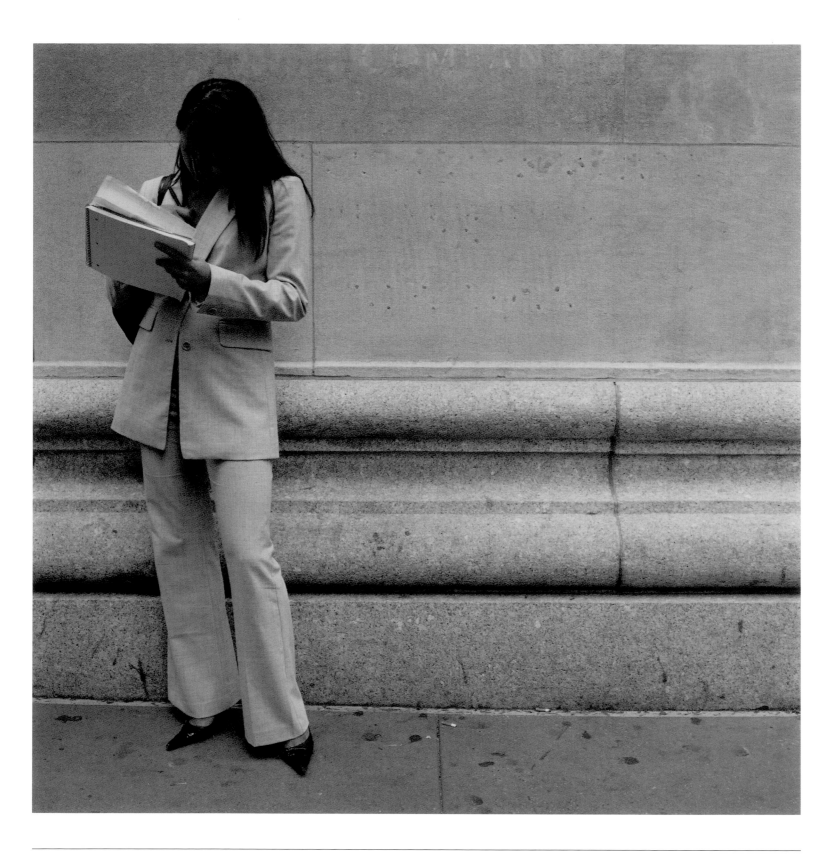

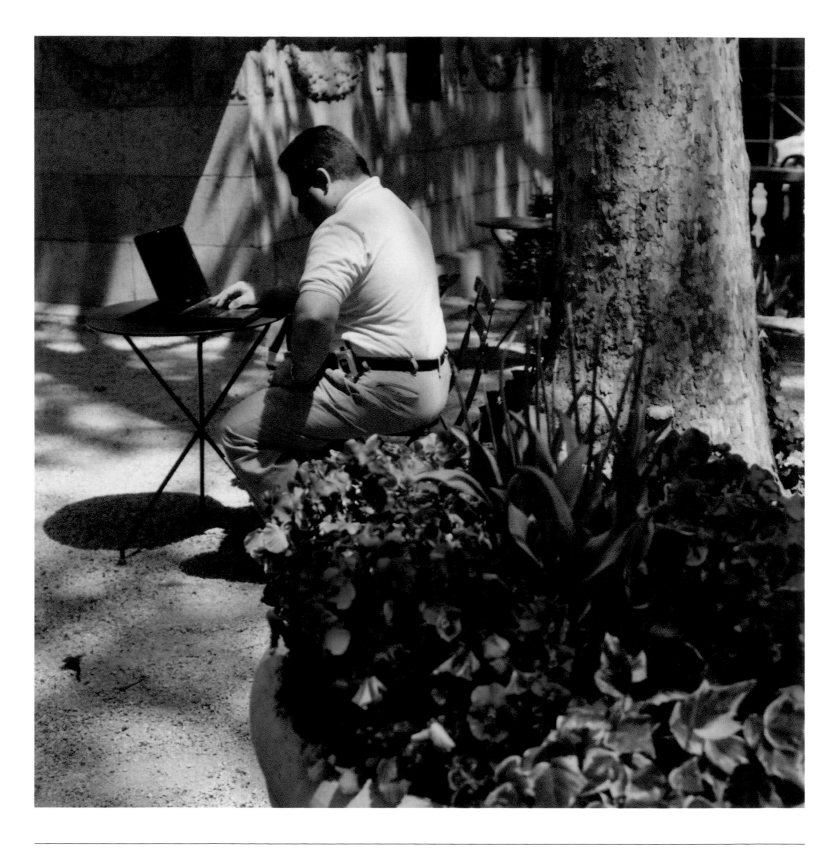

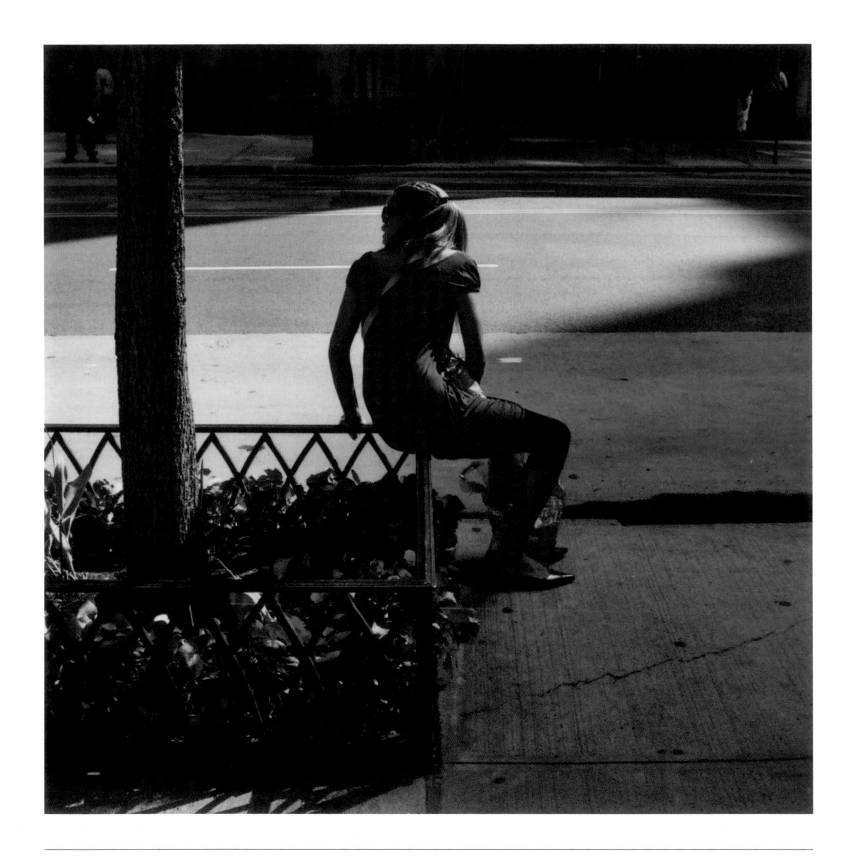

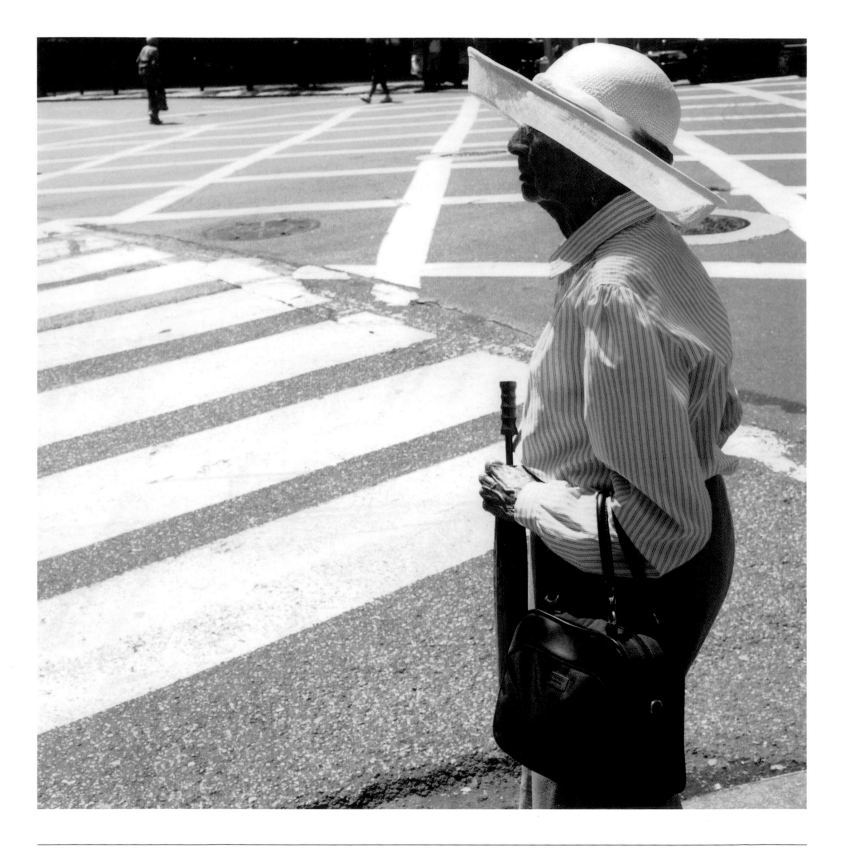

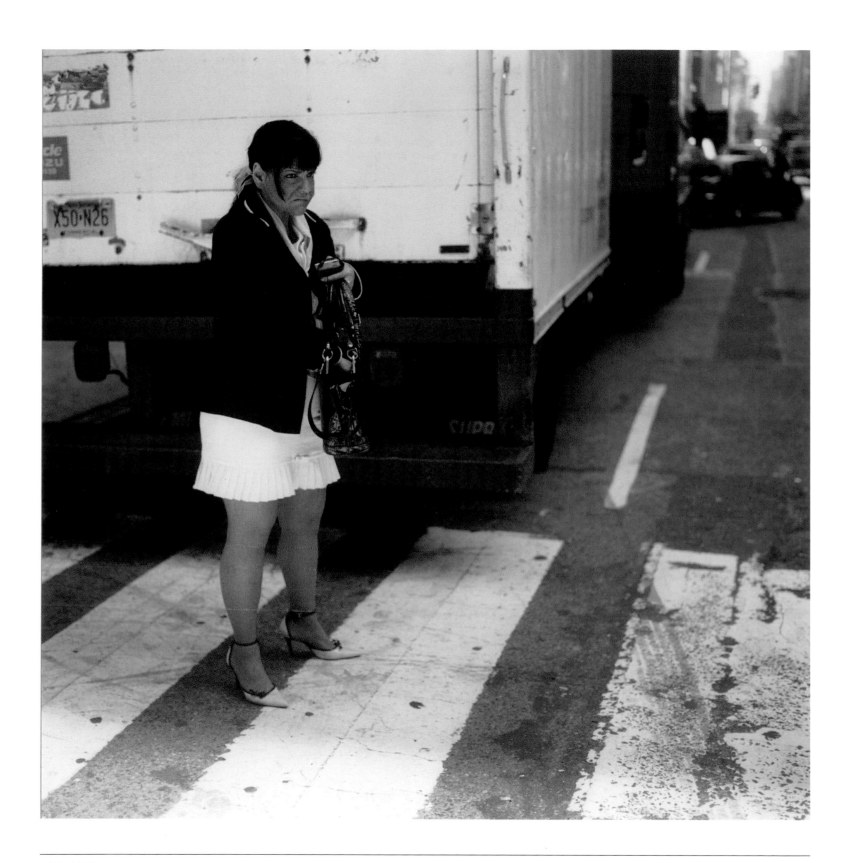

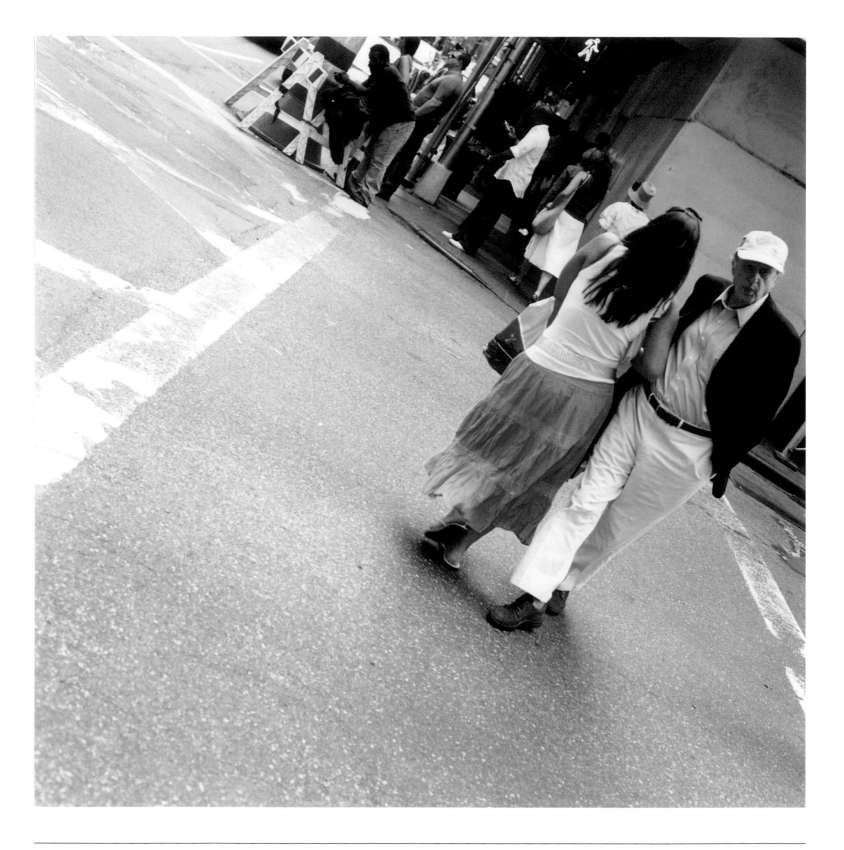

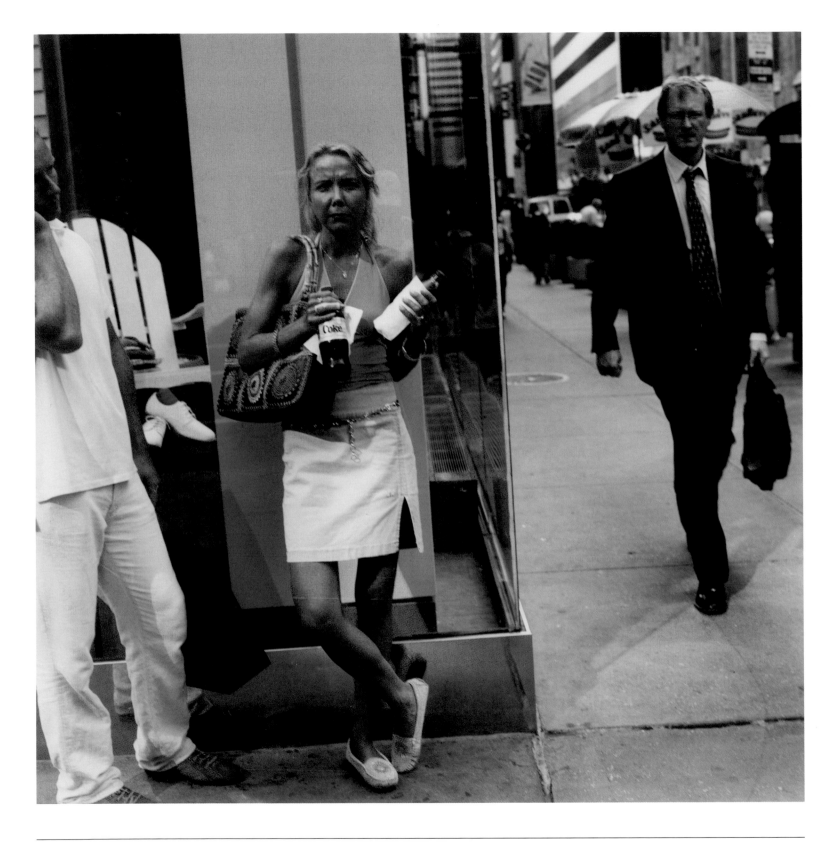

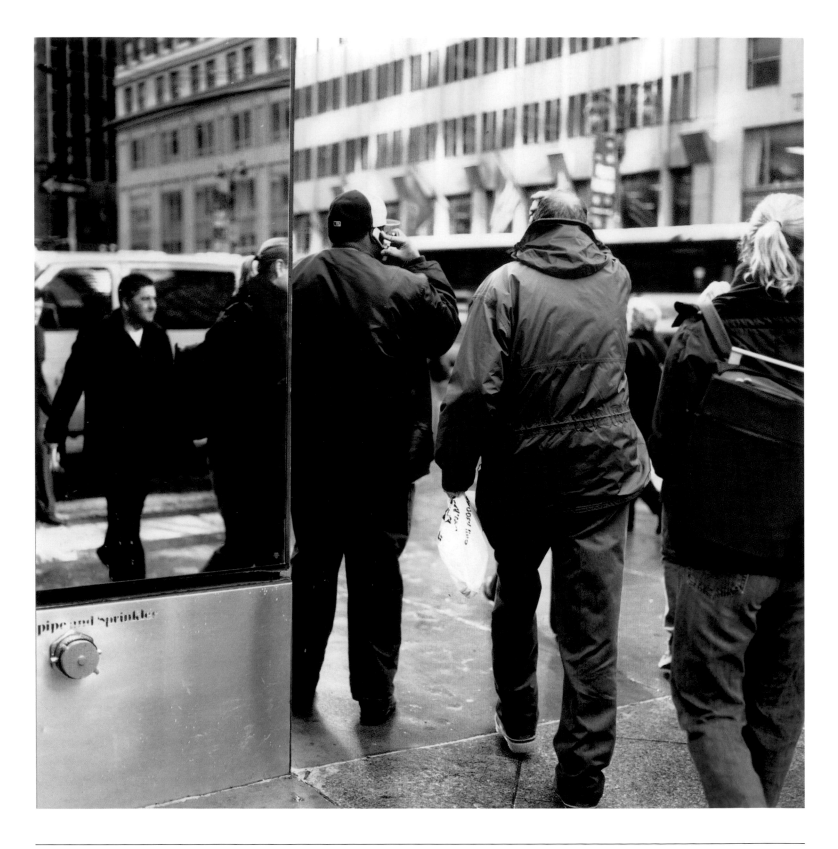

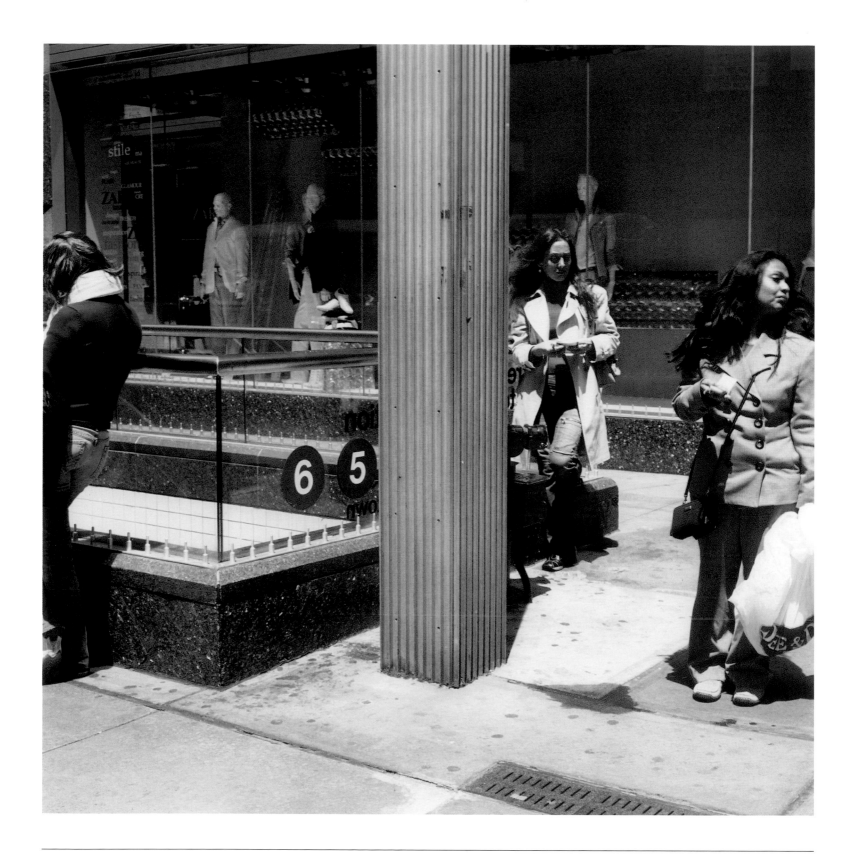

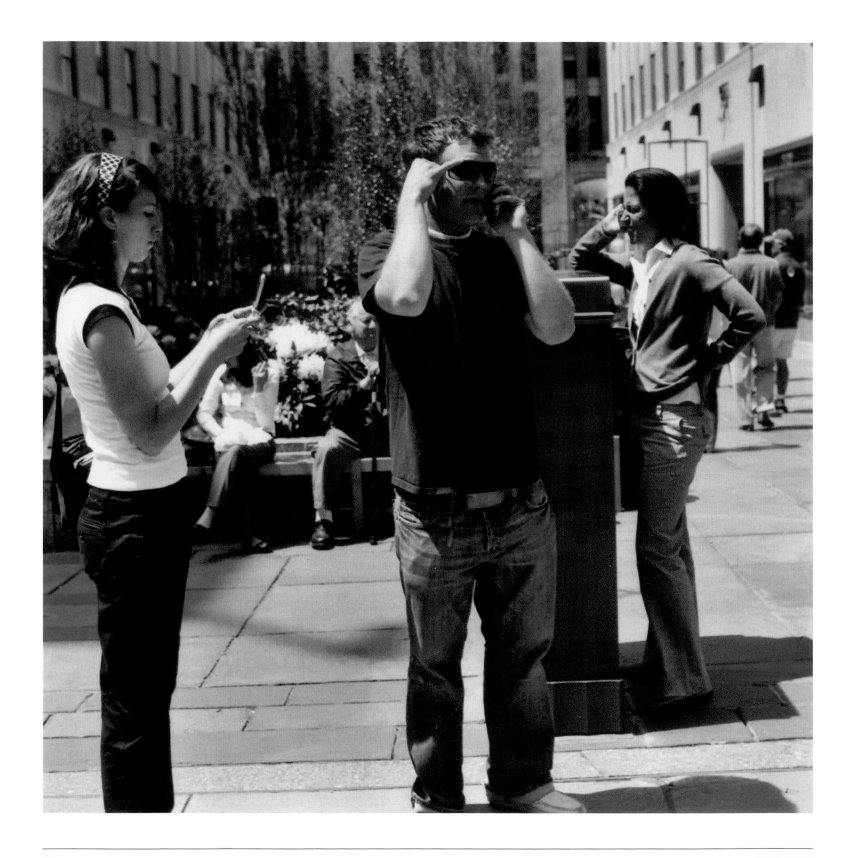

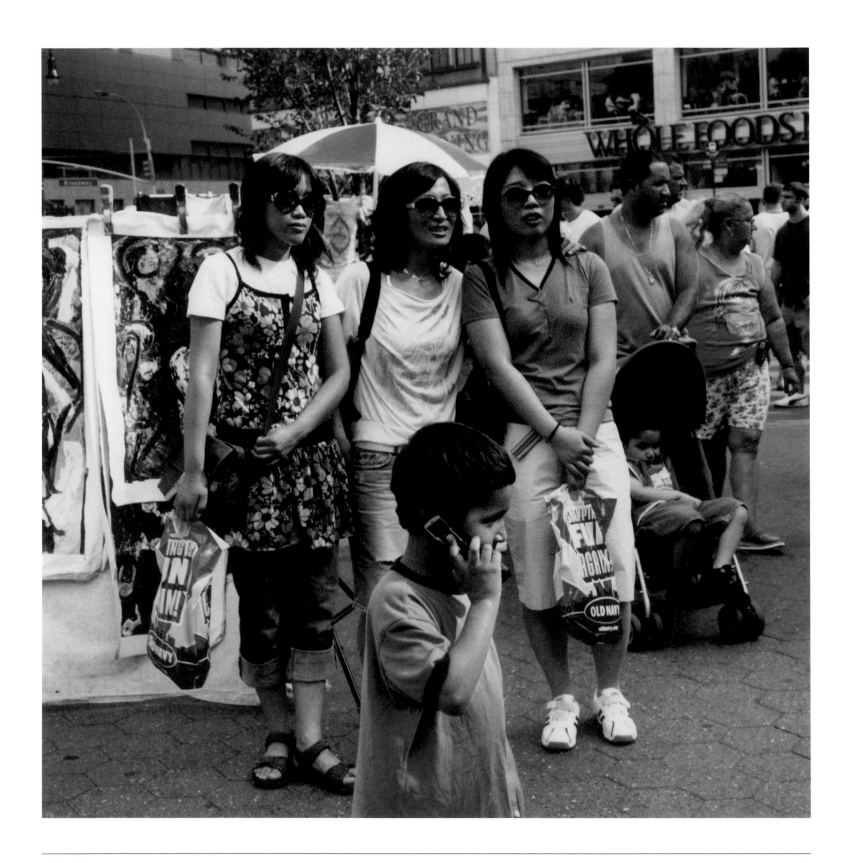

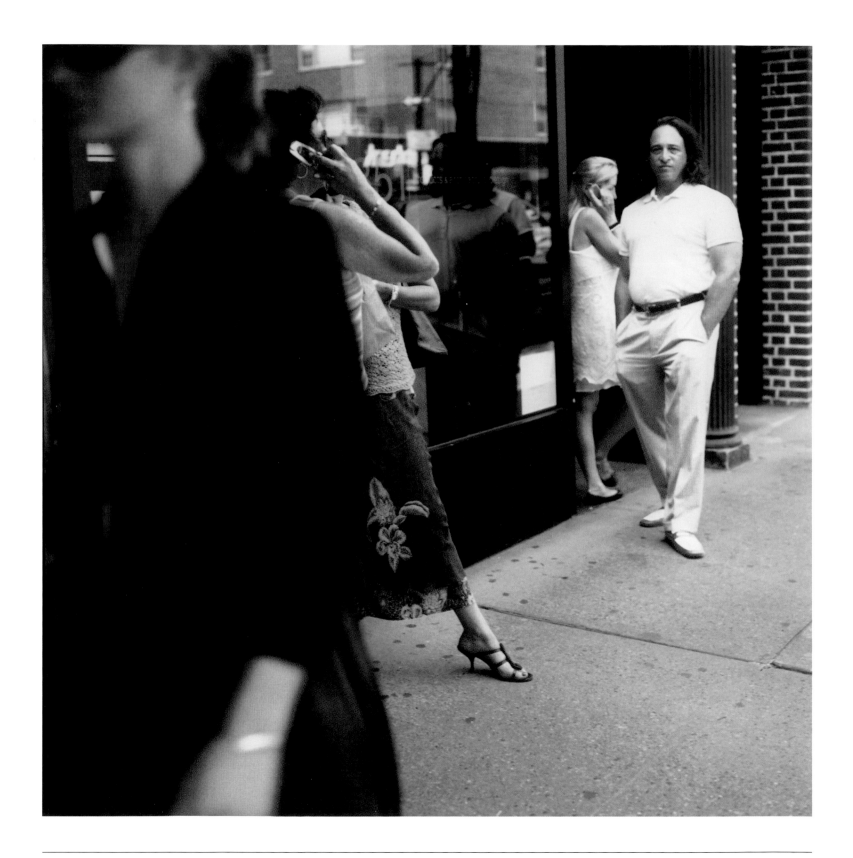

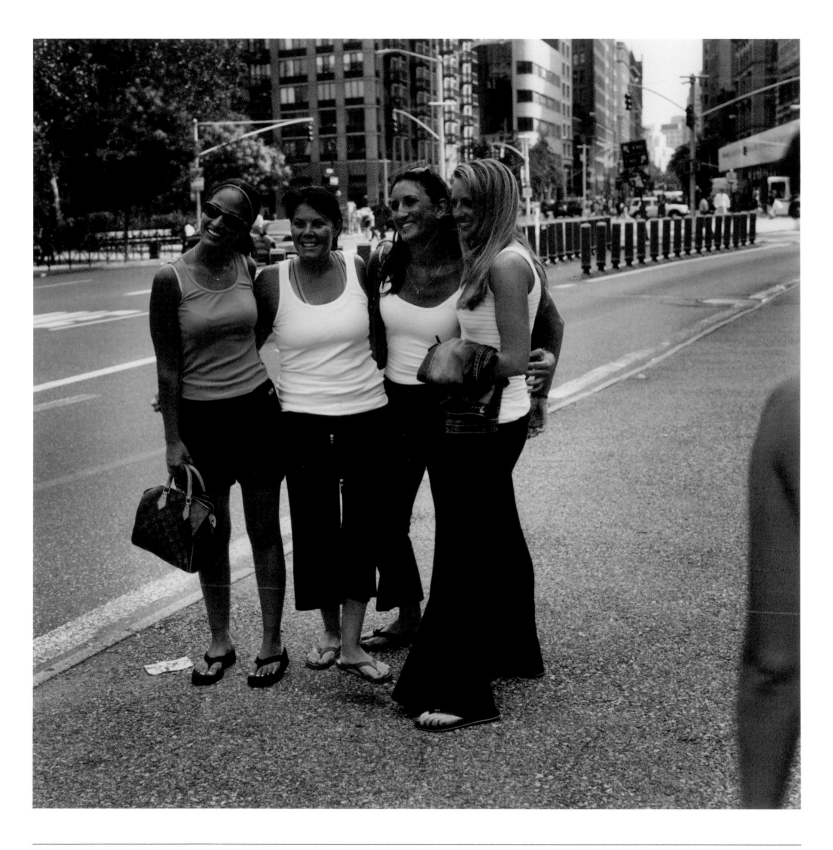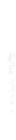

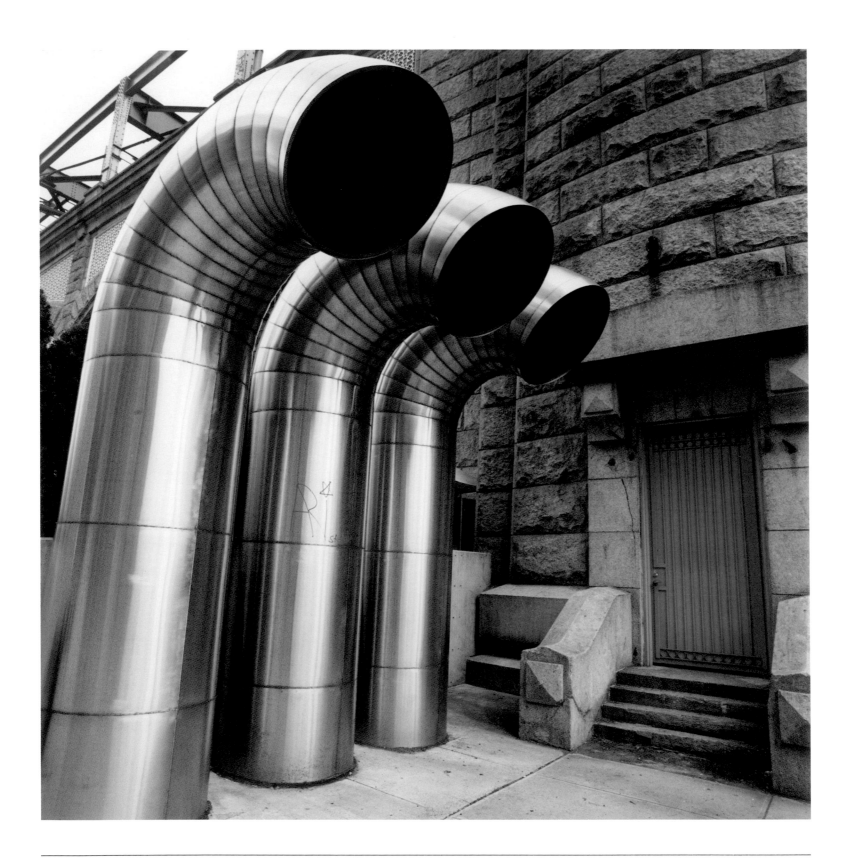

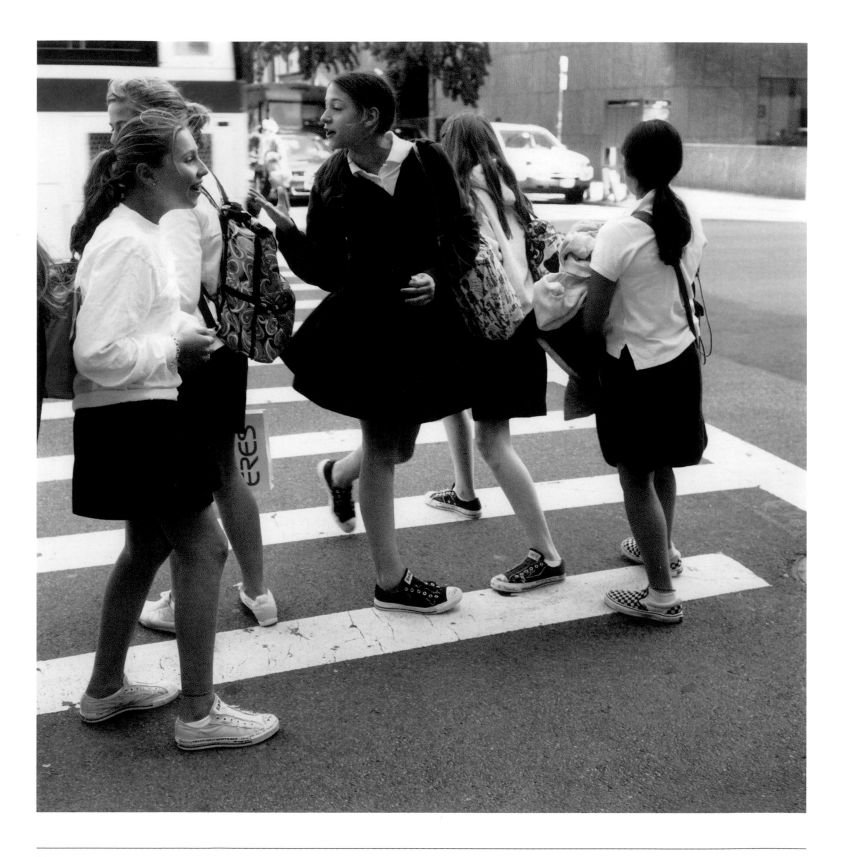

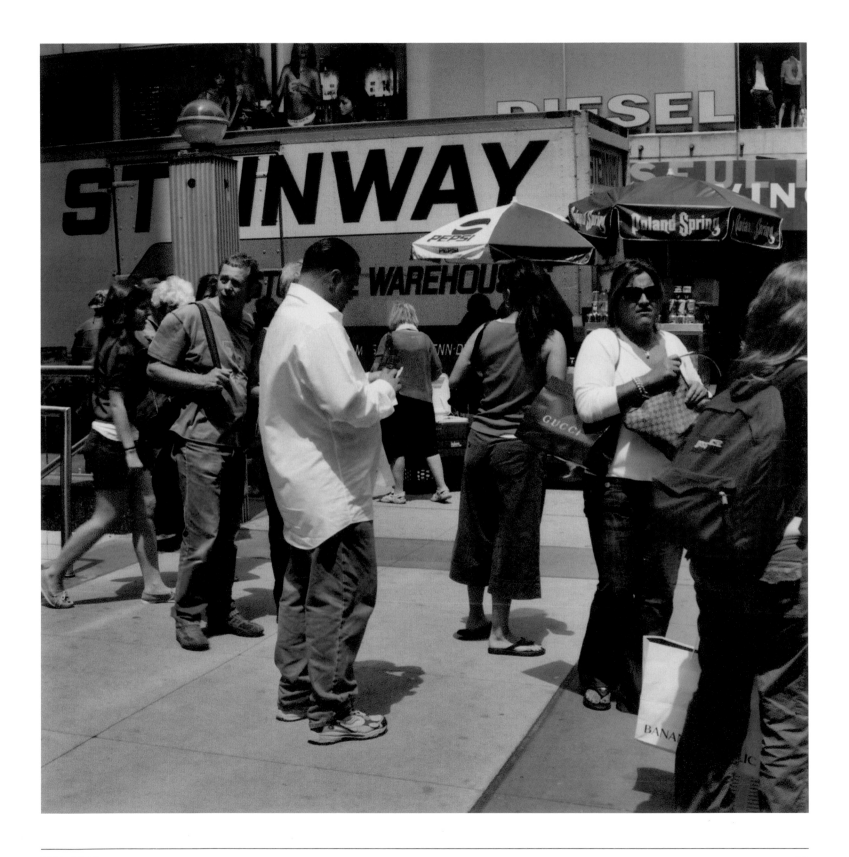

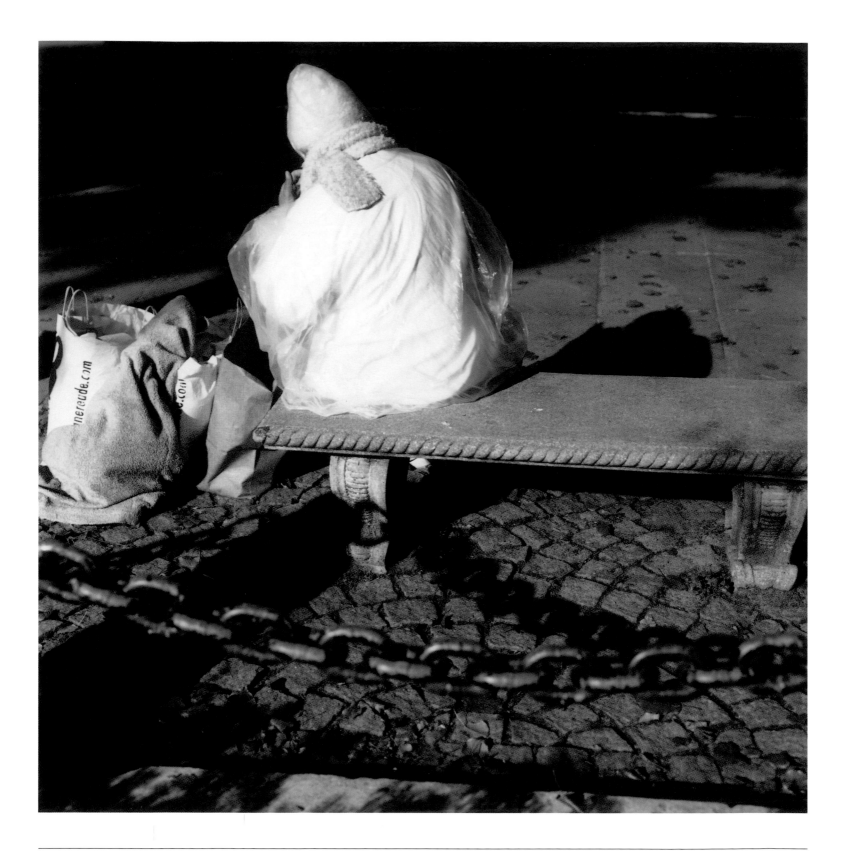

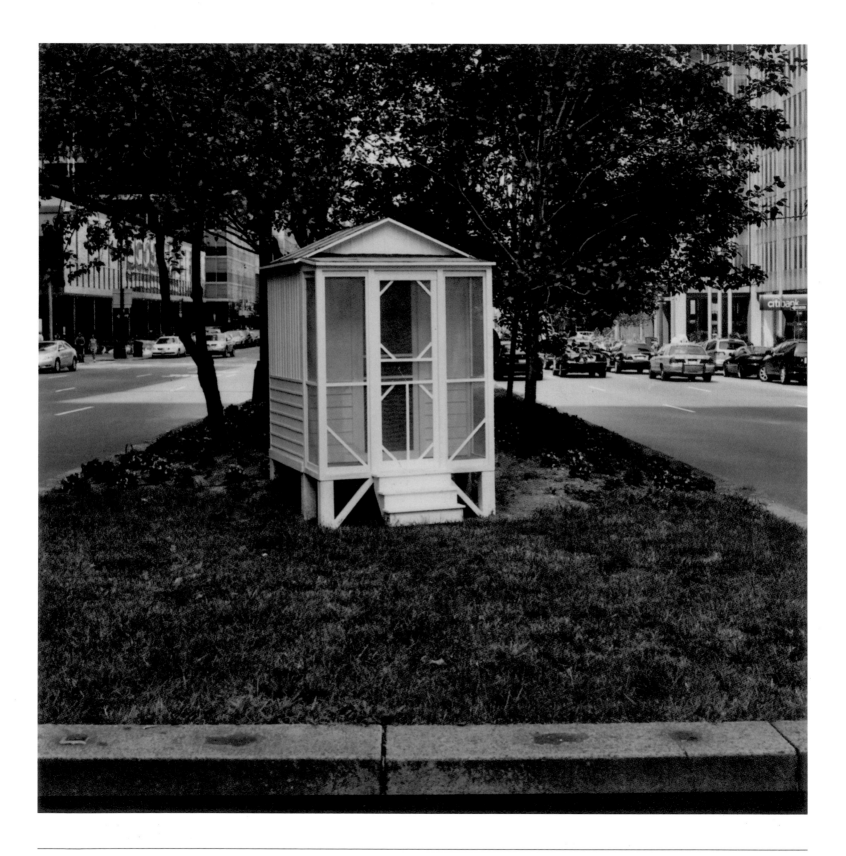

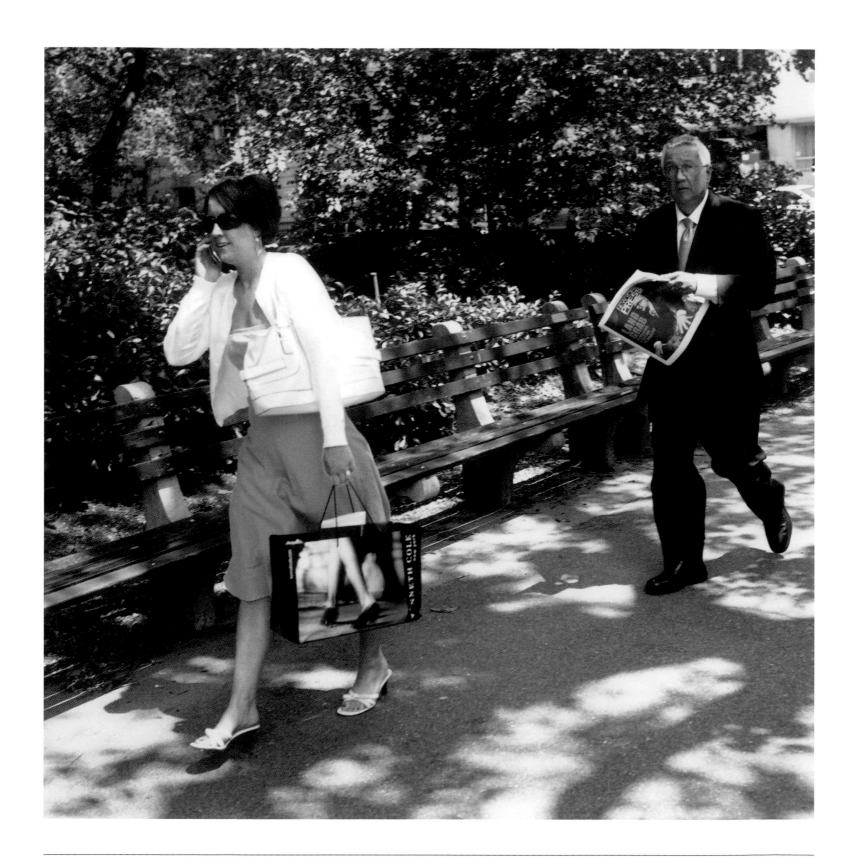

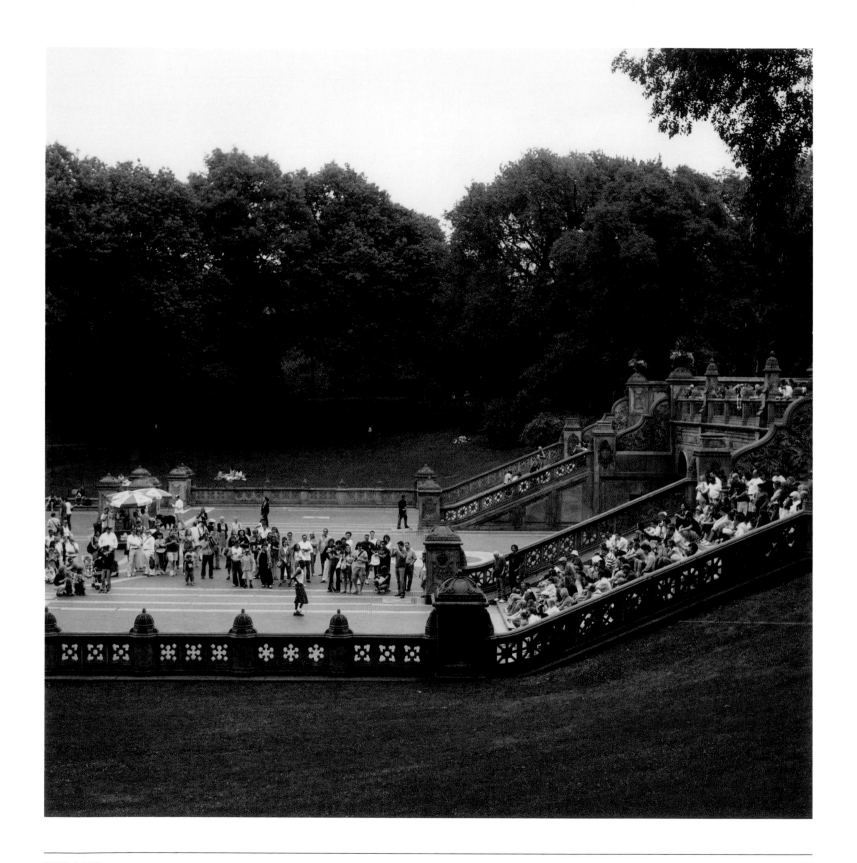

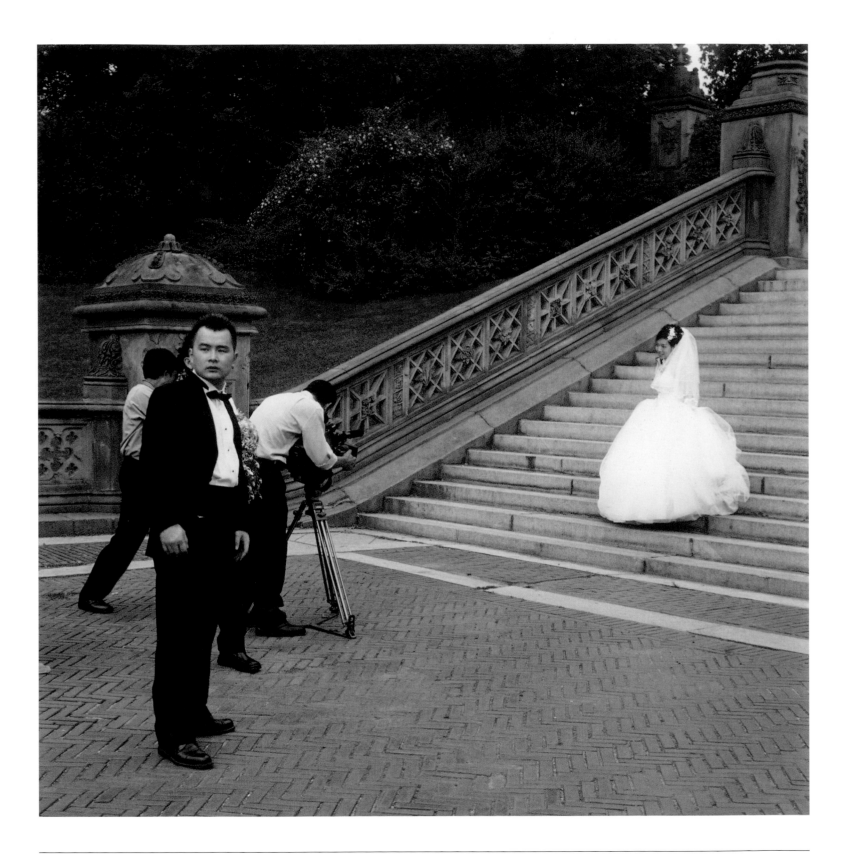

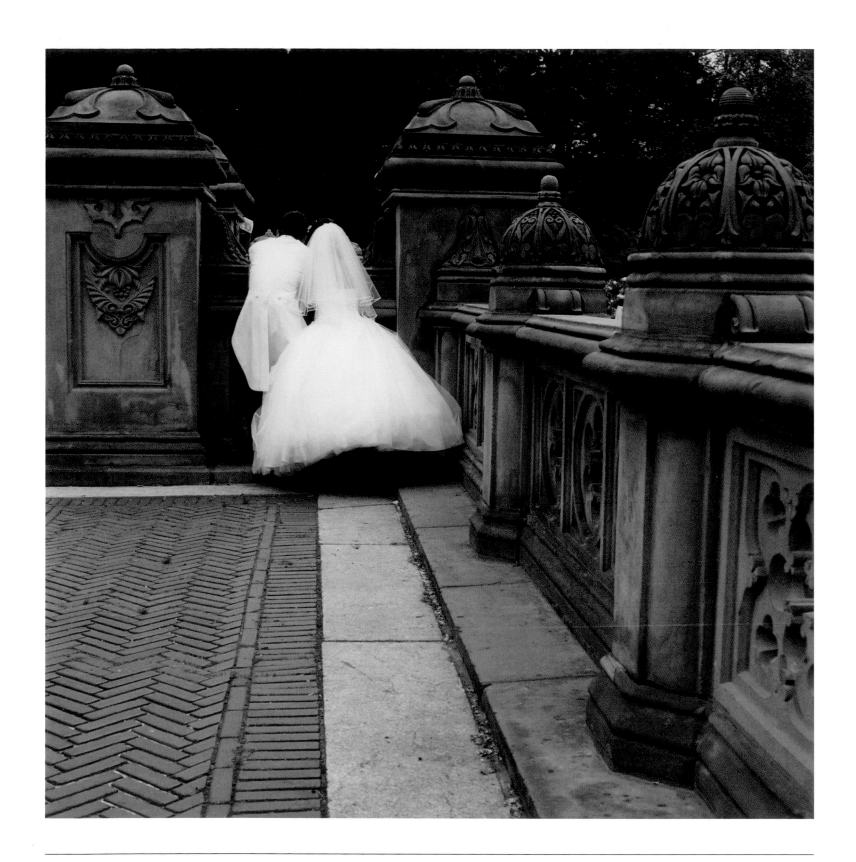

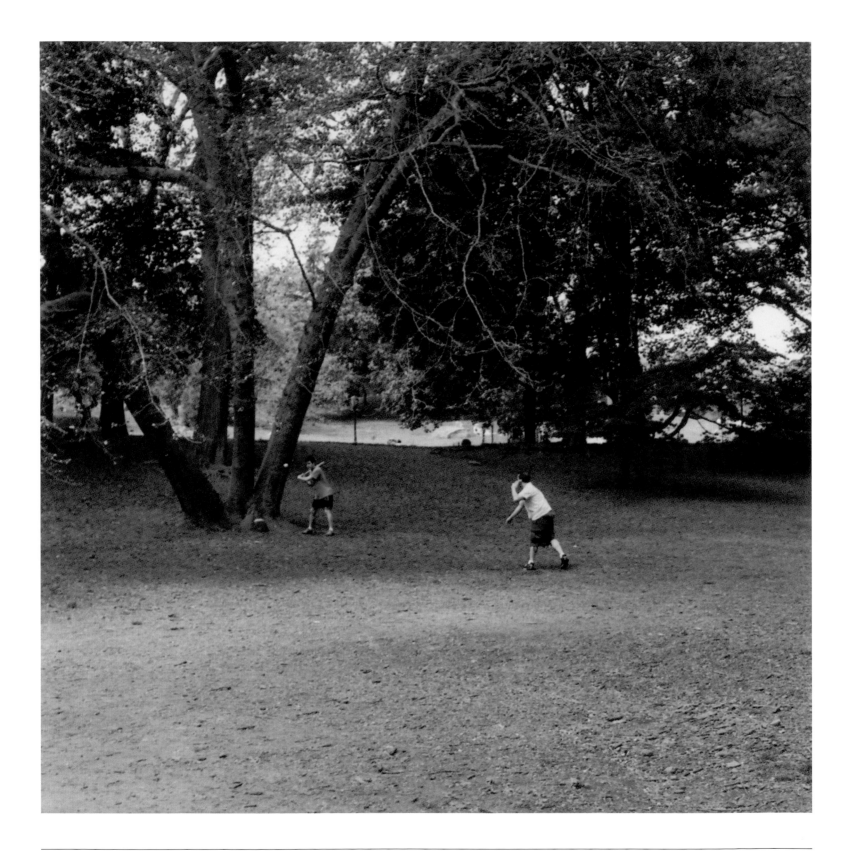

Larry Merrill

Larry Merrill was born in Brooklyn. He has had solo exhibitions at Bard College, the George Eastman House, the Manes Gallery in New York, the World Bank Headquarters in Washington, DC, the Yale University Global Fellows Program, the ARTECO Institute in Cumberland, MD, and the M. Early Gallery in Rochester, NY.

His work is in the collections of the George Eastman House, The Israel Museum, the Minneapolis Institute of Arts, the Museum of the City of New York, the Museum of Fine Arts in Houston, TX, Yale University Art Gallery, and the World Bank.

He was guest curator at the Metropolitan Museum of Art of *The Camera and the Photograph: Images in Light,* in the Uris Education Gallery. He has photographed for the World Bank in Senegal, Peru, Haiti, and Bhutan.

Merrill lives in Rochester, NY.

Acknowledgments

Everything about this book is better due to the generosity, wisdom, and talent, of many people. I would like to thank Kathryn D'Amanda of MillRace Design Associates, Michael Hager and Michael Shuter of Museum Photographics, and Marian Early of Custom Photographic Printing.

At the Memorial Art Gallery I am happily indebted to Susan Dodge-Peters Daiss, Marjorie Searl, and Grant Holcomb. Finally, my friend "by inheritance," Wendell Berry.